Those
Who
Can,
Teach

Those Who Can, Teach

What it Takes to Make the Next Generation

Andria Zafirakou

BLOOMSBURY PUBLISHING
LONDON · OXFORD · NEW YORK · NEW DELHI · SYDNEY

BLOOMSBURY PUBLISHING
Bloomsbury Publishing Plc
50 Bedford Square, London, WC1B 3DP, UK
29 Earlsfort Terrace, Dublin 2, Ireland

BLOOMSBURY, BLOOMSBURY PUBLISHING and the Diana logo are trademarks
of Bloomsbury Publishing Plc

First published in Great Britain 2021

A catalogue record for this book is available from the British Library

ISBN: HB: 978-1-5266-1406-3; eBook: 978-1-5266-1402-5

2 4 6 8 10 9 7 5 3 1

Typeset by Newgen KnowledgeWorks Pvt., Ltd, Chennai, India
Printed and bound in Great Britain by CPI Group (UK) Ltd, Croydon CR0 4YY

MIX
Paper from
responsible sources
FSC® C020471

To find out more about our authors and books visit www.bloomsbury.com
and sign up for our newsletters

This book is dedicated to my greatest
teacher – my Yiayia

Contents

Prologue

The road to Downing Street feels longer than the return flight to England. I am in the back of a taxi after a whirlwind twenty-four hours. The tarmac judders under the wheels of the black cab on the M4 – much as it had as we came in to land just a couple of hours ago at Heathrow Airport. My feet finally touching firm ground. Or perhaps not quite yet.

I have just returned from Dubai where I won the Global Teacher Prize – nicknamed the Nobel Prize of teaching – and now I am on my way to Westminster to meet the prime minister, Theresa May.

We cross a flyover and I look down. That's the exit I would ordinarily take to head towards my classroom at Alperton Community School in Brent. Left at the roundabout, a short weave through familiar housing estates and shop-lined streets to my art department, my comfort zone. Yet we're heading away from the school I love, speeding towards central London, where the prime minister awaits.

It doesn't seem real.

I am not quite sure, even now, where this all started. How I was picked from more than 30,000 others – an arts teacher from a London school. I have blurred memories of the moment that my name was called, of a speech I had pieced together, of the cheers, the celebrities, the well-wishers backstage, my fellow finalists and my parents' proud faces in the crowd – though we will come to that.

For now, I have barely slept because this girl – herself from an inner-city London school – had not wanted to miss one minute of flying business class, albeit on a red-eye flight, for the first time in her life.

In my hand luggage I'd packed a black dress and a gold-flecked jacket, which I'd changed into on the plane – I iron down the creases with my hands – and a beaded necklace, because I know this prime minister takes trouble over her own accessories. It's not so much about impressing her, but playing the part, not letting the side down. My make-up is freshly applied, even if my eyes are a little bloodshot from lack of sleep, and I'm surviving on adrenalin alone. In the cab with me are a handful of representatives from the Varkey Foundation, which is responsible for the Global Teacher Prize. We make polite conversation, but my stomach is turning – I would give anything to be heading the other way through traffic, home to my husband and daughters.

We push on through the morning rush hour. A few miles north from here is Camden, and St Michael's

Primary School, where I started my own education. I think then of the teachers who inspired me, those guardians of childhood who can make or break our experience of school. They are rarely praised for their efforts, yet I have just been awarded $1 million − £700,000 − for mine. The figure makes my head spin.

I was only ever doing my job.

Soon enough we're pulling into the gates of the Houses of Parliament. We're met by Barry Gardiner, the MP for Brent, and his assistants, who lead us into the Palace of Westminster and towards the public gallery in the House of Commons. We're seated in a special part of the gallery for VIPs, one without a screen, so it feels as if we're in the very heart of Prime Minister's Questions. Seconds later, Theresa May is on her feet, mentioning my name.

'I know members across the house will wish to join me in congratulating Andria Zafirakou, who recently won the Global Teacher Prize. It is a fitting tribute for everything she has done, and I look forward to meeting her shortly to congratulate her in person.'

Cheers from the MPs rise up from the floor and the CEO of the Varkey Foundation, Vikas Pota, turns to me and smiles.

Jeremy Corbyn, the leader of the Opposition, is next on his feet, informing the prime minister that he had already met me the week before.

'They're squabbling over you,' Vikas whispers.

We sit watching the debate until the prime minister leaves the floor, and one of her ushers arrives to collect me. I'm taken to her office. Inside it is beautifully decorated, all dark wood-panelled walls hung with rococo-style paintings. The fabrics are William Morris designs; even the carpet is thick and sumptuous. I think of the lino floors and breeze-block walls in my own school – a world away.

The prime minister puts her hand out, congratulating me again on my award. We pose for photographs and sit down on one of the sofas in her office. Her desk is scattered with paperwork, important documents requiring signature, a reminder that very few people get the opportunity to sit where I am sitting. I know I must use my time wisely. She wants to talk about me, but I interrupt to tell her about my school, about the students. I wonder how often – if ever – kids like ours at Alperton are represented inside the Houses of Parliament.

'In our borough in Brent there are more than one hundred languages spoken,' I tell her. 'Eighty of those languages are spoken at our school. For many of our students, English is an additional language and very often it's something they have to pick up at school, which is an initial challenge, and requires more time and support from teachers.'

I pause to see if she is taking all this in; she nods for me to continue, her brow crinkled in concentration. I'm aware of the clock ticking on the wall, her assistant perched on a chair nearby to tell us when our time is up.

'Our children have tough lives, Prime Minister. Brent is one of the most deprived boroughs in London: some students share homes with four different families, which can make it hard for them to find a quiet place at home to study. There are high levels of deprivation and poverty, and day to day we have concerns about gang violence and radicalisation.' I check them off on my fingers. 'But our school is theirs: it's the place they can be sure to get two good meals a day; it's somewhere warm; it's somewhere they can change their future. And the arts can make such a difference to their lives. I have students who have unlocked trauma through their artwork, who have spoken for the first time because they found a home in the art room...'

I want to tell her more. About how the arts help kids like ours, about how invaluable it is to children who don't speak English, or those with special educational needs and disabilities (SEND). But her assistant moves, gesturing to her that our time is up. As I leave, she tells me that I will be having a tour of 10 Downing Street, and then the schools minister has something special he wants me to ask me.

I leave her office wondering if I said too much, if I was too passionate, too fierce – too north London. I have that sense again that I am an imposter, that I don't belong here, that I am talking quickly out of some need to convince these people that I am worthy, but perhaps I'm still trying to convince myself.

We walk along the Mall to Downing Street and I stand outside that infamous black door. The second it opens, my eyes are wide – there is so much history inside this building. I pass by Winston Churchill's leather club chair in the lobby, then down a corridor past a Henry Moore sculpture. We continue further into the house, past more sculptures, this time by Barbara Hepworth, and paintings by Lowry. I stop in front of one of them.

'I teach my children about this painting,' I say, taking in every brushstroke of its industrial scene.

I follow Nick Gibb, the schools minister, up that famous yellow staircase – a reminder of Hugh Grant dancing down it in *Love Actually* the only thing grounding me in this world in which I feel so wholly out of place. Every inch of these walls is covered in famous portraits of former prime ministers, all of them painted by lauded artists. Even the ceilings are decorated in ornate cornicing the like of which I have never seen before. These artefacts belong in a gallery – they are the type of things my students will have only ever seen in books.

Together with Nick Gibb and the representatives of the Varkey Foundation, we drink tea and eat biscuits in Winston Churchill's old bedroom, which is now one of several meeting rooms. I smile at all the right times, careful not to put a word out of place. But being on my best behaviour feels exhausting, and I long for the safety of my classroom, the smell of pots of paint and pastels, turpentine and school dinners.

Nick and I met just a few weeks ago when I found out that I had been shortlisted for the prize. I'd had to put my prejudices about the government away that day, because under Michael Gove, when he was education secretary, Nick Gibb had implemented the English Baccalaureate (EBacc), a qualification that has put emphasis on core subjects such as English, maths and science, which has meant having to forsake some of the more creative, practical subjects in schools. I had tried to talk to him about what it had done to my school at our first meeting, tried to explain what it had taken away from the students. But this man's mind was not for changing.

Today he is all charm. We celebrate my award, and he recites the history of this famous building and many of its former inhabitants. Then suddenly, apparently with some trepidation, he takes from inside his blue suit jacket a piece of folded-up paper. This must be what the prime minister had mentioned.

'Andria, we would like you to help us with a recruitment drive,' he says.

I stare at the piece of paper in his hands. On it is a mocked-up photograph of a teacher posing. I assume they want that teacher to be me. Among all of the surprises today had in store for me, I had not expected a job offer from the government. This feels like the kind of thing you see in films: a meeting in Downing Street, wined and dined, then told what you can do for your country.

All eyes are on me as I hold the piece of paper in my hand, and for the first time that day, and quite unusually for me, I don't know what to say. Something – instinct? – is stopping me from saying yes.

'Thank you,' I say instead. 'I'll think about it.'

I hear a short intake of breath around the table, and then silence follows. The schools minister wriggles a little inside his suit. In that small gesture, I sense that for him – and perhaps even for the prime minister herself – my acceptance of the job was a fait accompli.

Vikas is the first to speak.

'Could you give a reason as to why you would like to think about it, Andria?'

I have been concentrating so hard all day on doing and saying the right things. I have focused on smiling, on being the person they expect me to be, on toeing the line and being on my best behaviour – which is not how I usually get things done. It is not, in fact, what won me the award. But surely these people know that? I wouldn't be here now if I had toed the line, if I had smiled and said yes and no in all the right places, if I had been on my best behaviour at all times, if I hadn't pushed for more in my school or gone above and beyond to care for my students. Breaking the rules was what brought me here. From this side of the table, I am not even sure whether I am the authority on teaching that they think I am, and for a moment, I don't know what to say in answer to Vikas's question.

But then a vision of my school and all its students flashes into my head, and I know that is the one thing that I am expert in – the lives of my students – and the fact that this very government, the same one that is trying to woo me into working for them now, has done nothing to help my kids succeed. In fact, they have taken away far more opportunities than they have given.

The people who sit in 10 Downing Street are like gods to us teachers. They are the decision makers – but we are the people on the ground living with the consequences of their decrees. How ironic that in a building where so much emphasis and importance is put on art, decor, painting, sculptures – a place where they want to surround themselves with all these beautiful things – I need to remind them just how important the arts are to young people. I wouldn't be here if it wasn't for my students, and this is my one opportunity to speak for them. I take a breath, unsure what exactly is going to come out.

'I don't think this government has done enough to support the arts,' I say.

The room is silent. I turn to the schools minister: 'For example, you introduced the EBacc, which has destroyed textiles. The British fashion industry has some of the best designers in the world, yet you have killed the textiles curriculum for kids. My curriculum. Where will these designers of the future come from now?'

Everyone around the table looks a little awkward, but I continue.

'In my world, I teach children who have English as a second language, and the arts are one of a handful of subjects, alongside maths, that give them a level playing field. Why is that not important to the government?'

'Well, evidence shows that—' Nick Gibb starts.

But I don't give him a chance to answer. This is nothing to do with evidence and paperwork; this is to do with the students I teach every day, who are missing out because of some decision made in rooms just like these.

'What about the kids with special educational needs and disabilities?' I say. 'Those who need to spend extra time on a piece of work, the ones who otherwise are written off? My subject gives them time to make progress, to give them confidence, to show them they have skills and potential just the same as everyone else. Why is that not important to the government?'

The schools minister takes a look around the table. Does he realise that all the EBacc certificate has done is heap pressure on kids who are already struggling, and increased the workload of teachers who are only just keeping their heads above water?

'Well,' he tries again, 'evidence shows that children who do these subjects will make faster progress and go on to get better jobs...'

He starts quoting facts and figures, and as he does, I feel myself switching off, because that is not my experience in the classroom, that is not what I know of school life. How could I have possibly felt an imposter all day when these

people – the decision makers – know nothing about the realities of being a teacher? When I speak again I know I'm more passionate, more fiery, and, I'm aware, more north London than Downing Street – but I am speaking up for the children I have taught. Education is not about government statistics; it is not about schools meeting targets, about assessments and league tables, Ofsted and EBacc, or even – I glance at the piece of paper still in my shaking hand – recruiting teachers. It is about the students. It is about real human beings, and we teachers are already doing our best to help these kids – not always with the support of their own parents – and we need all the help we can get. So I speak for many teachers, too, and for all my colleagues who have burned out through stress. This might not be what this minister wants to hear, but it is the truth.

'What about the mental health of teachers?' I say. 'What are you doing about that? Their workload is increasing, they're working their holidays just to keep up.'

I pause, and see, for the first time, every face staring at me. I know then this is not the time or the place. I am not winning. Not on this occasion, not in here. Everything I have kept bottled up, not just today, but for the duration of my fourteen years' teaching, has just been laid bare on this table. I realise then that this award does not represent the pinnacle of my career. This is just the beginning. A turning point.

I think about the prize money. If the government isn't going to do anything to help these kids, then I will. Every

day when I step into that school, it is not just about what I am – or rather, what we are – teaching them, it is about what the students teach us. And I owe it to those students to use my winnings wisely.

By the time I arrive back in Brent, the sky is black and the glow of lights from the window of my home is a welcome beacon. I knock on the door, and my husband throws it open, and on sight of his smiling face, I burst into tears.

'What's wrong?' he asks.

'I think I'm going to be assassinated by MI5!' I say, collapsing into his arms.

He laughs, and says exactly what I need to hear: 'Let me pour you a glass of wine.'

I'll give myself this evening to celebrate with my family, and tomorrow the hard work begins. I am not someone who has toed the line and I never will be. It doesn't matter what government policy says: this teacher from Brent is determined to preserve the arts for our kids – because experience has taught me just what a difference it makes to their lives. And now I am going to tell you.

One

In November 2007 a tall, skinny boy with curly black hair walked into my classroom. I had, by then, been a teacher for two years – the story of how I got started we will come to. But I am starting here because, despite the fact that I was supposedly the professional, this fourteen-year-old boy taught me one of the most valuable lessons I have learned throughout my teaching career.

Alvaro looked very smart compared to my other pupils, a couple of whom raised their heads from their work as he walked in. The reason he looked so dapper was because he was sporting a crisp new school blazer emblazoned with the Alperton Community School logo. Each intake of pupils in Year 7 gets a blazer given to them by the school. There has been much talk over the years about whether pupils should wear uniform, but in my school, it is a vital leveller. For these young people, it is one of the most important gifts we can give them – a symbol that no matter your background, you deserve the same opportunities as the person beside you.

Alvaro's blazer fitted neatly at the cuffs, unlike those belonging to some of the other kids, who had been wearing the same blazer they were given aged eleven, their parents unable to afford another throughout the five years they would stay with us. Experience had taught me that these same students would be wearing their Year 7 blazer in Year 11 when they left the school, a length of their forearm exposed where they'd grown out of it over the years. That's why we always see the Year 7 pupils in a blazer two sizes bigger, and why Alvaro's – who had joined in Year 9 – now fitted him perfectly.

Alvaro had joined our school from another one in the London borough of Brent, one especially set up to deal with those with special educational needs and disabilities. In collaboration with the local authority, my head teacher had agreed to take an additional ten pupils from this local special educational needs school into Alperton. The reason, I have to admit, I was unsure of at the time. After all, these kids weren't expected to sit GCSEs; they did not have the ability and would only ever leave school with entry-level certificates, subject qualifications a rung down from GCSEs. In a public service – which, like many others, earns its stripes based on results – if anything, these ten children would adversely affect our position in the school's league tables. But the head teacher had clearly put social inclusivity before ticks in boxes. In short, she wanted us to help these ten pupils succeed in a mainstream school. She wanted to

give them the same chance as everyone else. Who could argue with that?

I knew little about Alvaro before he walked into my classroom. I had read his notes, but the only thing that leapt out to me from his records was that he was electively mute – a child who refuses to speak in almost all social situations, a condition often associated with anxiety. I was used to talking to children who didn't speak English, but this was different. I had no experience or special training to deal with a child with this condition, and that morning perhaps I hadn't known quite what to expect. Little to nothing was probably my answer. My expectations of these kids and what they could achieve were low.

Alvaro arrived late to class alongside his teaching assistant, and I directed him to a spare desk at the side of the room. His TA left him once he got settled, and I made my way through a well-worn pathway between desks to hand him a worksheet. I smiled, I welcomed him, I placed the worksheet in front of him along with a few pieces of A3 paper. He didn't look up. Instead he stared straight ahead, his eyes glassy, refusing to make contact with my own. Alvaro wasn't like the rowdy boys I was used to. I clocked a couple of the other students' eyes flickering towards his desk. I understood how intimidating it must have been for him to walk into a new classroom with all these people he didn't know, and so, without much fuss or fanfare, I put a couple of

bottles and a jar on his desk, and told him that we were drawing still-life objects.

'Have a go,' I said, and then I went to help another student with his hand up on the other side of the room.

I watched Alvaro from my vantage point, but he didn't move, just continued to stare straight ahead. Who knew then that this silent boy would change the way I taught for ever?

In my classroom I want to inspire creativity. We play Kiss FM or Classic FM while the kids hum along under their breath. I have one rule that when the chatter gets so loud that I cannot hear the music, the radio goes off. It's a good way to keep the kids in line. My desk is draped with beautiful fabrics, and hanging on the wall alongside classic works of art are my students' attempts at their own masterpieces. It is a colourful room. But it hasn't always been like this.

When I arrived for my first interview, fresh out of teacher-training college, I felt intimidated and scared. In fact, I wanted to turn around and leave. The school then was in a faded old brown-brick Victorian building, with huge panelled windows in every room that had long stopped fitting the mortar of the place and now refused to open. Instead, the only airflow came from the broken panes of glass, and so − I would later learn − there were two seasons at Alperton Community School: summer, when the place felt like a greenhouse, or winter, when

the freezing air would rush in and pupils shivered while they worked in their coats. What did the windows matter anyway? They were so dirty, it was impossible to see outside. And did we even want to? My school is not surrounded by lush green hills, but an urban land-scape: the back of Alperton Tube station, traffic, trains, concrete, noise and black pollution, and more recently, fly-tipping. Back inside the classroom the walls were painted a dingy green and the lino floor was ripped in places. The class work that was on the wall was sun-bleached and criss-crossed with dust and cobwebs, and the place smelled musty and damp from the rotten wooden units that held the ceramic butler sinks together in the corner.

I didn't want to stay. I had come here from a teaching placement at a very different school, where every room was equipped and fitted out with the latest technology. It had been too easy, yet left me feeling out of my depth. My own schooling had been in an inner-city primary. As a girl I had attended St Michael's Church of England School in Camden Town, and that part of London wasn't the popular tourist trap it is now. Back in the eighties it was a total dive. My family had migrated from Cyprus to England in the early seventies, and my grandparents had bought an apartment in a big Georgian house in College Place for just £5,000. The reason they – and many other Cypriots – had settled in Camden was because it was close to the only Greek Orthodox church in London – later, my father would be priest there.

Although I was born in London, being part of a huge migrant family meant I always felt like the outsider. But that wasn't a bad thing. Camden in those days was a dangerous place: we never went out after dark. The streets were sprayed with graffiti and people used to steal from the church. There were mornings we woke to the news that another body had been found in the council bins. But it had a real sense of community, a sense of acceptance, that difference should be embraced and not feared. We respected one another.

In my class at school, I cannot think of one English kid. Instead, we were a mix of Bangladeshi, Irish, Chinese, Somali, Pakistani and Greek children. The teachers at our school had been there for their entire careers; they had taught our siblings, our cousins, our parents before them. Within every school day was stitched a rich history of our family that teachers would call on to remind us where we came from. 'You're a chatterbox, just like your cousin,' was a comment levelled at me often. And yet it made me feel safe and secure that my teacher knew my family so well, that she understood where I had come from.

Because, back then, the teachers didn't move around schools like they do now. Their classrooms were a home from home, and they decorated them in their own unique style. One of my favourite teachers was Miss Matar. She was an Englishwoman who dressed every day in Sierra Leone gara cloth robes, and heavy beads that jangled when she walked. On her hands she wore oversized rings

that sparkled, and her classroom was decorated with beautiful draped fabrics in wild, bold colours, complete with a reading area made cosy with rich, earthy-toned upholstered cushions.

Miss Calder in the room next door loved her plants, and kept boxes of bright red geraniums on every windowsill. I would put my nose right up to those petals, frustrated that something so beautiful refused to release a scent. But it was the perfect place to study, a sumptuous, colourful and bright learning environment. Every child – though many came with their own unique challenges – was treated equally. Our diversity was celebrated, our different faiths encouraged. I would go home to my Greek mum after school and teach her Diwali songs that I'd heard my friends singing in the playground.

To go from that to teach in a school with children from predominantly middle-class backgrounds seemed as if I were dialling down the vibrancy of school life. Not only that, I would feel intimidated, as if I were not worthy of teaching children that I had so little in common with, let alone facing their parents. Perhaps, in some ways, arriving at Alperton Community School was akin to me coming home, returning full circle, back to a school like the one I had loved so much as a child.

So I changed that Victorian classroom. I stripped the walls so they could be painted and then draped them with rich fabrics, like those I'd remembered from my school-days. I found a corner to display my own artwork, so the

children would see that I too was a work in progress, and in a nod to Miss Calder, I put flowerpots on every windowsill. I breathed life into that classroom, and I saw the difference it made to the kids. Because otherwise, what would it tell them about themselves if I put such little effort into the room I invited them into? I like to think my classroom told these kids they were worthy of respect and effort.

I kept my eye on Alvaro throughout the lesson, but unlike the other kids who were head down, working, he sat staring straight ahead. I went back over to him, realising he had no pencils of his own.

'Here, Alvaro,' I said, 'use some of these pencils.'

I scattered some in a pile on his desk. As I walked away, he picked one up tentatively, as if he had no idea what to do with it. Instinct told me to leave him to acclimatise, to allow him to slowly become accustomed to his new environment. I had received no training on teaching SEND kids; often – as in life – we teachers are left to rely on our intuition. We see enough children coming through our classrooms day in, day out, year in, year out, to understand what humans want and need. But back then I was relatively new to the job, still feeling my way, not entirely confident that I was doing the right thing for each and every one of my pupils.

I watched Alvaro, and after a few minutes he started to draw. Towards the end of the class, I wandered around the room, taking a look at what each student had done.

When I reached Alvaro's desk, I had to squint to see the image that he had committed to paper. In the middle of the sheet of A3 was the tiniest jar, not much bigger than a postage stamp. But it was the attention to detail that surprised me: the curve of the lid perfectly drawn with sensitive strokes; a 3D image starting to emerge from a full hour of drawing. Not that it was finished. Its size was troubling, though unsurprising. As an art teacher, you learn to read a lot about a child by the way they draw. This huge sheet of white paper with just a tiny object in the middle of it told me just how little confidence Alvaro had about being here. How small he felt in my class.

But I also spotted something else – talent. Some children could never manage to draw a 3D object, so there was definitely potential here. But how to bring this boy out of his shell? I had no idea if it was even possible.

'This is a good start, Alvaro,' I said, then I went to the art cupboard to get him some supplies. I made him a folder and pressed on a sticker with his name written on it. Inside I slipped a sketchbook and put it on his desk.

'Your homework is to draw me another object,' I said, aware that I was speaking more loudly and over-pronouncing my words in a way I wouldn't with any other student. I worried that I sounded patronising, but how could I be sure that he understood the instructions? I had no idea at that point whether there was any cognitive disorder.

'Do you understand?' I asked.

He continued looking straight ahead.

At the end of the class he crept away without a word.

The following week we continued our still-life theme, only this time I changed the paper to black and gave the kids some white and grey oil pastels so they could practise shading and toning. Alvaro was sitting at the same desk, and I saw beside him the plastic folder that I had given him the previous week – so he had been able to remember that.

I demonstrated in front of the class and then started going around each desk to help students with their sketches. By the time I got to Alvaro we were midway through the lesson. He sat silently, of course, but I noticed his shoulders were more relaxed than the previous week. Some progress, at least. He was concentrating on his work, and when I looked closer, I saw what it was, a barely there drawing, as small as the last, but he had made the mistake of using his lead pencil on black paper.

'Alvaro,' I said gently. 'You can hardly see what you are drawing. Why don't you try this white pastel instead?'

He shook his head quickly, clutching his pencil tightly, as if he were afraid to exchange something he had got used to for this new, strange crayon. I left him to it. Perhaps he preferred that almost invisible drawing. Perhaps he wanted to disappear into the walls of this classroom unnoticed.

During the lesson I collected the homework. I stopped beside each desk, commenting on what each student handed in. But when I approached Alvaro, he had nothing

ready to hand to me. He kept his head down, absorbed in his work.

'Did you do your homework, Alvaro?' I asked. He didn't speak, just shook his head into his drawing.

I walked away. He wouldn't have been expected to do homework in the school he had come from. Perhaps it was an alien concept to him.

As the children filtered out after class, two of the girls hung back to discuss their projects with me. I was talking to them, looking at their work, when, out of the corner of my eye, I noticed Alvaro pass by my desk on the way out. He left something on the corner, I had no idea what, and my eyes flickered over to it. What I saw took my breath away – a pencil drawing of the body of an electric guitar, effortlessly captured where the light fell on it, shaded and toned in perfect, beautiful detail. He must have spent hours on it. He had signed it 'Alvaro'.

'Alvaro!' I shouted. He was heading to the door but he stopped stock-still.

In my excitement I left the two girls and dashed over to him.

'Did you do this?' I said, quickly.

He didn't answer, just stared, facing forward. No eye contact.

I moved in front of him, waved the picture in his face.

'Alvaro,' I said, 'this is brilliant.'

Slowly, for the first time, his eyes met mine.

'Did you really do this?' I asked.

11

He nodded.

'How long did it take you?'

He didn't answer.

I bombarded him with questions. Was it his guitar? Had he downloaded the photograph from the internet? How did he know how to shade it so well? Had he got more like this?

He searched the classroom with his eyes, shifting from foot to foot, as if hoping someone might rescue him. Instead, from the other side of the room, the two girls heard my excitement and rushed over to start complimenting him too.

The bell began to ring, but I couldn't let him leave, not yet. I dashed to my cupboard and grabbed as much equipment as I could lay my hands on: a box of oil pastels, some watercolour paints, brushes, different paper, charcoal, more pencils. I hurried back to him.

'This is what I want you to do,' I said. 'Draw more for me. Draw anything. Your favourite things, your house keys, your football, your earphones, anything you like. Do you understand?'

He stared at the equipment I was pushing into his folder.

'Do you understand, Alvaro?' I said again. 'I want you to draw five things for me, anything you like. Can you do that?'

He stared back at me for a second, then nodded. Then he snatched the folder from my hand and scurried out of the room.

'Miss?' one of the girls said beside me, and I remembered suddenly the students who had waited so patiently to see me.

That night, long after Alvaro had left, I still held his picture in my mind's eye. Had I really underestimated him?

Every lesson I planned, I kept Alvaro in mind. I thought of his tiny sketch in the middle of that huge A3 sheet of paper, and knew that I needed to find a way of building his confidence. One of the ways I decided to do this was to get him using different materials, so the following week I asked the class to paint a still life. I demonstrated, as I always do, and then wandered around the class checking everyone's work. Only when I got to Alvaro, he sat staring at the brushes and colours.

'I thought you might like to try painting this week,' I said, perching on the corner of his desk.

Alvaro shook his head.

'I can't get you a GCSE unless you show me the other things you can do,' I said to him.

He sat staring straight ahead.

'OK, let me start it off for you,' I said, knowing it was not ability but confidence that he lacked.

I dipped the tip of my brush into the paint, and dragged the inky end of it along the paper.

'There,' I said, handing it to Alvaro. 'Now you try.'

He took it from me, tentatively touching it to the paper, then traced a line around the other side of the bottle he was drawing.

'Good,' I said, moving on to the next desk. Only when I looked back a second later, he had put the brush down.

I went back to his desk.

'Great, now what about this bit?' I said.

He didn't respond, so again, I picked up the brush and painted the line in myself, then handed it to him, and watched how he did the same.

'Brilliant,' I said, wandering away.

I looked at the work of another couple of students, and then my eyes flickered back to Alvaro. He was sitting there staring at his piece of paper again. I knew then I would have to guide him through this, that he would only paint another brushstroke if I did one for him first. So that is how we continued throughout the lesson: for every line I made, he matched it with another. Slowly though, they grew longer and broader as he grew in confidence over the next hour. I was aware of other hands up, desks I needed to reach, and I had to juggle Alvaro's needs with those of all my other students. At the end of the session, I was rewarded.

I was leaning over another student's desk, when I felt a presence behind me.

'W... where do I put this, miss?'

'Over there, on the rack,' I said. But I didn't recognise the voice that had asked me. When I turned

around, I saw why. Alvaro had spoken. This boy, who was mute when he had first come into my class, with special educational needs and few expectations of himself, had spoken to me for the first time – art had done that. I didn't say anything, I didn't want to make a fuss or embarrass him. I noticed he had a stammer – perhaps that's why he preferred not to speak. But he had talent. He had potential. How foolish I had been to underestimate him.

Alvaro continued attending my classes, and each week I saw his confidence grow. It was as if, with recognition of his talent, he felt worthy in other areas of his school life too. I saw how he made friends; I watched him in the canteen at lunchtime interacting with the other kids; saw how he played football in the playground during breaks. He didn't shuffle into my classroom any more – he strode in, chattering with the others with a sense that he deserved to be there. The day that I told him off for talking, the entire class burst out laughing.

'Oh my God, Alvaro,' I said. 'I just told you to be quiet.'

He blushed with embarrassment, but smiled, with his crooked teeth and train-track braces.

We pushed on for the next two years, and when GCSE exam time came, he took his place among all the other students. And Alvaro, who had never been expected to take an exam, got a grade D. His mother turned up with him to collect his results.

'Thank you, thank you,' she said, wrapping me in a hug.

Alvaro couldn't stop smiling all day. Out of all the exams that he had sat, this was the only GCSE that he had got.

The head of the department, Armando, came over to congratulate him.

'You know, he was only three points away from a C,' he told me.

'A C? But if he'd got a C he could have sat an A level,' I said.

My colleague nodded. And I felt a spark light up inside me.

'We should do it,' I said. 'We should try and get him a place on the A-level course. Would you like to do that, Alvaro?'

His face told me everything I needed to know.

That summer I lobbied the head teacher to allow Alvaro a place on the A-level art course. Eventually she called me and said that if I thought I could get him through, she was happy for me to give it a go. She wanted his classes timetabled, so that he could resit his English and maths GCSEs at the same time.

'No problem,' I said.

Alvaro became a regular fixture in the art rooms. Whenever he had a spare period, he would be sitting at the back of our classes, working on his portfolio or trying to improve in some way. The younger students loved having him there – he got a reputation for being our artist in residence – and they would often go up to

him during class for help, or ask him how he managed to draw or paint the way he did. It was a joy to see how he interacted with them. His stammer would disappear. He seemed perfectly at ease in that mentoring role.

On A-level results day, I was lying on a Greek beach where my parents have a holiday home. My sister, Maria, is also a teacher and our phones buzzed in unison when the results came in. Most years' results coincide with my annual holiday, and the rest of the family know not to bother Maria and me as we scan through the grades, frappés in hand, sand between our toes. When I spotted Alvaro's name, I jumped up and screamed. People must have thought there was a shark on the beach.

'What is it?' Maria said.

'Alvaro got an A!'

I saw Alvaro a few weeks later when he came into school to collect some of his work and sort out his folder. I'd never seen him smile so much.

What Alvaro had taught me was invaluable. It is often those who have special educational needs who are so easily underestimated – hadn't I done that myself when Alvaro first walked into my classroom? Yet he had proved me – and everyone else – wrong. He had gone on to get an A at A level when he had never even been predicted to gain a GCSE.

The statistics for children with learning difficulties can make uncomfortable reading. They are twice as likely to

be bullied at primary school; they are seven times more likely to be excluded from school; they are twice as likely to live in poverty, and less likely to be employed. It wasn't just me back then who had low expectations – so does society. And teachers are not being equipped to help support them. A 2015 review remarked on a woeful lack of training for teachers of SEND kids, concluding that 'good teaching for SEND is good teaching for all children'. Five years later, I have not noticed any improvement in teacher training.

There are kids like Alvaro at school every day, sitting at the backs of classrooms trying to blend in with the walls, or too afraid to make a sound for fear of being noticed. Alvaro had retreated into a silent world because he thought he didn't deserve a place in the real one. So often we can overlook students like him. Teachers can be so hectic and buried in other work that we can't afford to give the Alvaros the time and patience they so desperately need. But look at what they can achieve if we do.

Alvaro's is a very human story, but it fundamentally changed the way I thought about teaching. I vowed that I would never again judge a child on first impressions. But the reality of what lay behind the disguises many kids adopt at school, I had yet to learn.

Two

Mohammed Abdul was a giant of a child. He looked much older than his years. He was Algerian, and had dark Mediterranean skin and huge brown eyes. He stood out from almost every child in the school, mostly due to the sheer size of him. Compared to students from other schools, our kids tend to look ten years younger, simply because they're not fed enough, often due to economic pressures on parents. In contrast, Mohammed looked ten years older. He smoked too, and, despite the fact he was only thirteen, his index finger was stained yellow with nicotine. He joined us in Year 9 when I was the head of year. I interviewed him, his mum and his elder sister when he joined the school. None of them could speak much English – Mohammed and his sister spoke only the very basics. His mum said nothing during our interview; she just sat quietly in her wheelchair while her children translated the odd piece of information to her. There was no father to speak of: Mohammed was the man of the house.

There were no problems that I picked up on during the interview, but it is only once the children start school that the reality of their situation becomes apparent.

It is no exaggeration to say that many of the kids in our borough are battling unbelievable levels of poverty. It is an achievement in itself that they get themselves to school each morning. These are kids who are fighting against the odds to get a decent education. They may be the ones caring for a parent, rather than the other way around. And they may have been through hardships that the rest of us are fortunate enough never to have experienced, or even known. As a result of meeting kids like this throughout my teaching career, I have learned more than anything to be kind in my classroom, because I never know what a child has been through to get themselves into school that morning. If they aren't wearing a perfectly pressed uniform, or if they are a few minutes late, I resist calling them out on it. Who knows what they have left behind at home that day?

Most people assume that migrants leave poverty to come to this country, but that wasn't the case for my family and countless others. My grandparents left Cyprus in 1959 before war broke out on the island. My family knew what it was like to leave everything that you have ever known, and growing up a third-generation migrant, I remember how those scars were felt in our home. In some ways the pain was defining. It meant that my grandmother insisted

we hold on more tightly to our Greek Cypriot identity. We went to Greek school twice a week – dance was our favourite lesson – and we were only allowed to speak Greek at home.

'School is where you will learn English,' my uncle would say, chastising any of us he overheard answering in English.

My grandmother was always cooking, replicating over and over those Greek recipes that she had made at home in Famagusta before it became famous for being a Mediterranean ghost town, homes abandoned mid-dinner – they said for years afterwards that through the windows of some houses you could still spot tables laid with plates and cutlery. Not everybody left. My mother's aunty was an old woman. She refused to leave the only home she had ever owned and was shot while she stood guarding it. Her Turkish neighbours, whom she had lived happily beside for decades, buried her body under a pile of rocks, granting her the dignity in death that she had been stripped of in life. I grew up with stories like these, bitterness folded into the traditional Cypriot savoury pies that we made. I remember another tale, of a neighbour who had been given moments to leave her house in Cyprus. She dashed back inside one last time to get what she considered their most precious things – her daughters' exam certificates. Even in times of war, education is still highly valued. If she was being forced to start a life in another country, she would make sure that she gave her girls the best chance at a future.

As my grandmother rolled out the dough, she would tell us of the paradise island that they had left, of the people still there, trapped living in the south, who grew geraniums in empty olive-oil cans, determined not to put their roots into the earth until they were back in the homes they'd had to abandon. My grandmother went back once and found another family living in the stone house that she had loved. She told us about it as I spooned filling into the flaounes – amazing savoury pies with cheese and raisins, which are often made to celebrate the end of Lent – and my sister, Maria, brushed beaten egg onto the tops. She described the curtains that hung at the windows, the precious silks and fabrics she had left behind. My grandfather was a potter, and people would buy his vessels to stuff with meats and cheese and bury them in the ground as make-do refrigeration, preserving them for months.

'Oh, the food we have buried on our land,' my grandmother would say, raising her hands to the heavens.

Cyprus was better than England, every beach a paradise, the sea more blue than anywhere else in the world, the sand finer. She would look around the tiny apartment we were squeezed into and remember the garden they had in Cyprus, an orchard filled with orange trees as far as you could see. Chickens, pigs and turkeys. A clay oven in the garden, which would be filled all day with terracotta pots bubbling with the dishes she now recreated in her tiny gas oven.

'If only I still had my oven in Cyprus,' she would say sadly.

On market day she would pick up fruit and shake her head: 'Call this a tomato?' she would say under her breath in Greek. 'In Cyprus our tomatoes are three times as big as these, and tastier.'

'And the cheese in England,' my grandmother would lament, shaking her head, 'it will do, but the cheese in Cyprus…'

She would kiss the air.

We'd listen to her stories one after another, if only to keep them alive in my granny's mind. It is not uncommon for migrants to hang on to their identity, their language, food and cultural traditions. Our only English experience was fish and chips every Friday – bought from a Greek chip shop.

We children of migrants often create two versions of ourselves – the person we are at home and the one we take out into the world. For me, the few times these two versions collided were the days when Grandma would pick us up from school and I would have to translate what the teacher needed to tell her about my day. Before the first day this happened, the teacher had no idea that I spoke two languages.

We were lucky. We didn't suffer the same discrimination others did. Cockney rhyming slang meant Greeks were known as bubble and squeak, or bubble for short; those names washed over me as a kid, but I know my

mother hated it. I worried for my grandmother when she went to the market on her own; the only words she knew in English were 'hello', 'thank you' and 'Marks & Spencer'. Perhaps that is why I have always felt for the migrants arriving at our school – their mothers remind me of my granny. How lost they all must feel, thousands of miles from the home, the language, the friends they knew, often in conditions much worse than those they had left. But safer, better at least, the parents insist. I knew how much it would have meant to my grandmother to have been greeted by the teachers in my school in her own language. Perhaps that's why, in memory of her, I did the same for my students. I learned how to say 'hello', 'how are you' and 'welcome' in dozens of languages. I saw the difference that it made to parents and kids when they entered the school. Because as a child of a migrant, it is written into my blood and bones how isolating it can feel to arrive in a different country. Because I respect the resilience of people like my own family members who arrived with little more than £1 in their pocket and made a life where there was none. For that reason I have always believed the respect that exists between teacher and student should be mutual rather than one-sided.

I would get to know Mohammed well over the next few months because there was rarely a day when he wasn't sent to my office. I sensed trouble when he gravitated towards a particular group of kids. Imran Kane was the

boy who threatened to turn my hair grey that year. If anything went missing or was stolen, he did it. But he had perfected the art of the innocent look. He never owned up. He made you question yourself for pointing the finger at him in the first place, until you checked the corridor CCTV footage at the end of the day. Samuel Campbell was another one of the students that Mohammed instantly made friends with. He was untouchable both in and out of school. His mum was a proud Afro-Caribbean Christian, who raised a boy who was divine in her eyes, but in reality the only reason you could never pin anything on Samuel was because he kept his hands clean by getting others to do his bidding. You'd see the secret looks in the corridor between him and other students, that tip of the head. How did Mohammed fit in with these boys so quickly? Experience has taught me that certain characters of students gravitate towards each other. They are unconcerned with background – Samuel was Caribbean, Imran was Somalian and Mohammed was Algerian – but it is as if they share a look that says: 'I can work with you' or 'You might be useful to me'. There is a playground etiquette that dictates: keep your friends close and your enemies closer. But perhaps the main reason Mohammed was so popular was that he always had cigarettes, and that made him cool in most students' eyes.

Kids like Mohammed have a swagger about them; they walk with their chest puffed out like they own the corridor. There is usually a reason why they play up to an image: they

can't afford to make themselves vulnerable. Mohammed had to claim his position from the minute he arrived at our school. Around his neck he wore a big chunky metal chain, which in the eyes of the other students made him something. Perhaps it was a way of deflecting from everything else that he wore, better to make himself a somebody than be a nobody – especially in a school like ours. Mohammed couldn't fit into the usual school uniform – not even one of our blazers – so he arrived at school every day in the same clothes that he disguised to look like uniform: black jeans, a white shirt and an old black sweatshirt with a Nike logo on it that he had blacked out with a marker pen. His collars were grey with dirt. Wherever he went, the strong smell of body odour followed him. Teachers didn't need many reasons to throw him out of their classroom because of his attitude, but his lack of a proper uniform provided them with an excuse every day. And because he was perceived as trouble, he acted like it too. He would play up to the reputation he had, and would often land in my head-of-year room because of it.

'What happened this time, Mohammed?' I asked. 'Mr Smith said you threw a chair in his classroom.'

'Yeah? Well, I don't like him, miss – he cussed me.'

I had heard this story from him many times before. So many times that I had adapted my own timetable to make myself free when Mohammed had certain lessons, as I knew I would be called upon to mediate. Mohammed seemed to have a problem with male authority in

particular, and these were the classes he liked the least. He would turn up late for that reason. I always thought it was a positive that he got himself to his lesson at all, but other teachers didn't see it like that. Yet time and again Mohammed turned up, knowing that the minute he arrived, he would be challenged. They might take one look at him and say: 'No wonder you're late, look at your attitude.' Who would want to keep putting themselves in the same situation where they are going to be picked on? Wouldn't anybody snap after a while? Instead, Mohammed switched off, telling himself there was no point in being there, until finally, when the teacher went on and on, humiliating him in front of the class, he picked up a chair and threw it out of pure frustration.

'Where's your uniform?' I asked him.

'I haven't got none, miss,' he said.

I ran my eyes over the Nike logo that he had blacked out with a pen. His clothes were obviously never washed, his body odour now woven into every synthetic fibre.

'What are we going to do, Mohammed? Is there anything going on for you that I need to know about?'

I had been calling home for weeks, but I hadn't spoken to his mother.

'No point in calling Mum – she don't speak English, miss,' he said.

'Well, then she could come into the school and we could talk about this. We can get an interpreter?' I offered.

Mohammed slumped down in his chair.

'No point, miss. Mum's in a wheelchair, she got MS. And she don't leave the flat in case the landlord changes the locks.'

I fixed my gaze on Mohammed, and that mask that he wore slipped for a few seconds.

'You can speak with my sister, Leyla,' he said, and reluctantly gave me her number.

Leyla came into the school the following day, and Mohammed joined us in my office. Leyla was only a couple of years older than her brother. I could see underneath her perfectly made-up face that she was naturally beautiful, with dark curly hair. She wore long acrylic nails, big hoop earrings and tight jeans. Everything about the way she looked seemed at odds with the hardship she started to describe to me, but I knew every word she said was true. Leyla studied at college and worked in the evenings at a factory. Her small earnings were barely keeping the family afloat – I understood then why Mohammed's school uniform came way down on a list of priorities for them. While Mohammed finished his education, everyone was relying on her, and, just like Mohammed had told me, they lived in constant fear of being evicted by their landlord. My eyes flickered between the two teenagers in my office. I noticed the way that Mohammed acted around his elder sister: cocky at first – the boy that I had come to know – but as she started revealing more and more about his background, his vulnerability came into focus. Her English wasn't much better than Mohammed's, but

I could see she was being as open and honest about their story as she could, and how painful a tale it was to tell.

'We had a good life in Algeria, not bad, but not like this, not so poor,' she explained. 'Our father – he was already in London – he told us life was better here, that we must come. He could not send money for flights, so we take bus from Algeria. Is a long way, many, many days, more bus and more bus. Our mother very sick when we come to London. Our house is bad, cold and damp. And then our father, he have girlfriend here and he go with her. He leave my mother, he leave us. We're not even speaking English. We don't have job, money, nothing. We can't pay rent, and they throw us. Then we find another place, worse than first. I try to pay but we have not enough money. Our father is gone, he is not helping us.'

I glanced at Mohammed; he looked suddenly so different from the boy who normally strutted down the corridor. He had shrunk somehow in his chair, as if the telling of their story had undone the years and he was a boy again, rather than a teenager. It made sense that it was often the male teachers that he would argue with, why he would not respect their authority. How could he, when the one man who was meant to be a role model had left him, his mother and sister in such dire circumstances? There was nothing that I could do to ease the pain that they had met along their journey to this country; there was no salve to soothe it better. Accepting that is one of the hardest parts of being a teacher. But I thanked

Leyla for giving me some insight into why Mohammed behaved like he did. Was it any wonder that he had chosen a different persona to the vulnerable one that sat in my office in that moment? That he had created for himself a character that the kids would respect? He couldn't risk showing that unguarded boy that I had witnessed, frightened that he would return from school to no roof over his head – something that the rest of us take for granted. I glanced again at the sweatshirt that he wore for school, the lengths he had gone to, blacking out the Nike logo. He had tried, in whatever way was possible, to adapt the little he did have to fit in with our school rules, and yet every day he was chastised and punished for it. Perhaps they were the only clothes he owned.

'We are worried about Mohammed too, miss,' Leyla said, turning to her brother. 'He is sometimes not coming home at night. My mother is so worried, she does not know where he is, if he is in trouble.'

'Is this true, Mohammed?' I asked him.

He shrugged, slipping that familiar mask back on.

I could see why Leyla was worried, for a boy like Mohammed with little to lose and no income at home, it would be easy for him to slip between the cracks, to be targeted by gangs or earn much-needed money as a drug mule.

'Don't worry, Leyla, we will keep an eye on him. You can call us any time he doesn't come home and we can let you know that he is safe at school.'

After Leyla left and Mohammed returned to class, there was a part of me that wished I could share what I had learned about their life with his teachers. I wished they knew how many disappointments he had overcome, and how, through it all, he came to school every day against the odds. Perhaps if they knew, they would cut him some slack, they would understand – as I did – that there were more important things than uniform or lateness. I had a renewed respect for Mohammed and his family – not sympathy, respect. But at my school, guidelines state that I could not share this information with my colleagues. It would make both Mohammed and his teachers vulnerable. As head of year I was party to information on the background of children that I hadn't known before. If I passed on that information to a teacher, then they might change the way they treated Mohammed – or any child for which similar circumstances applied. They might, for all the best reasons, give him more attention or sympathy, and his peers might sense that something had changed and single him out. His teachers might accidentally mention it, embarrassing him in front of all his classmates, and with that we, as a school, would lose any trust we had built up with Mohammed. There are children in my school today whose parents are dying of cancer, but you wouldn't know it, their teachers wouldn't know it – not unless the student told the teacher themselves. The whole point of school is to get students through the day as a normal child. We want them to have a clean slate

when they walk into a new class, rather than pass on their personal information with each new school year. The most that senior leaders might tell teachers is that the child is a little vulnerable, and to let us know if their behaviour changes. But generally we try to let teachers get on with their main role, which is to teach. That's why we have pastoral leaders in school – to take care of other issues.

I now had more information about Mohammed, but I wasn't sure how I could use it to make his life easier. There were many days when Leyla called my office to check that Mohammed was at school, just as I'd promised she could. I'd find him in class and tell him his mum was worrying.

'I was tired. I fell asleep on my mate's sofa, miss,' he said. Mohammed mentioned that an uncle was now at their home and I wondered how much this affected his desire to be there.

Still, week after week, he ended up in my office for the same thing: his lack of uniform, his attitude, his tardiness. Until one day, it wasn't Mohammed that snapped, but me. It was the usual scenario: a teacher had complained about Mohammed and sent him to me. Another detention for not wearing the uniform.

'Why were you rude to sir?' I asked him.

'Miss, I can't stand him. He's always loud at me. He annoys me.'

I sighed. 'Do you think I like everyone I work with?' I said. 'No, I don't, but we have to be professional, we have to get on.'

He nodded.

'I can't push that person, or tell them to eff off,' I told him.

I could see that Mohammed was caught in a vicious cycle. The constant detentions weren't helping the situation: they were just feeding his anger, giving him another reason to hate school, another reason to leave. Even the place that we were trying to keep him in – because it was perhaps the only safe place he had – must have seemed to be against him. I could understand why he was close to just giving up. I looked at him sitting there in the same clothes I had seen him in for months, his shirt collar thick with dirt. There was no way he could win. There was no way this kid could feel normal, could have a day when someone wasn't on his back, unless I helped him break the cycle.

'Right,' I said, standing up and grabbing my handbag. 'I've had enough of all this.'

'Miss?' he said.

I stormed out of my office and the main building. Behind me I could hear his footsteps trying to keep up, but I got into my car and saw him in the rear-view mirror as I drove out of the car park.

I knew what I was planning to do, and that it might, to Mohammed, seem as if I was pitying him. I couldn't

allow him to think that. I had to allow him some self-respect, so instead I had to get angry.

As teachers we need to be able to desensitise ourselves to things, otherwise we would be too emotional about our job. We hear many stories of migrants like Mohammed making crossings, often dangerous, to reach a better life. We need to switch off our emotions at times, because otherwise we would simply burn out – and then how could we offer kids the safe haven they need? But here was a boy who was in my office almost daily. The only place I could allow sympathy was in my year room. Often he would turn up and Annette, my pastoral colleague, would just look at me and I would say: 'Yeah, just let him sit here for a while with us until he calms down.' It was better than the alternative, of him not being able to manage his anger in class, and doing something that would get him excluded for good. Then what would happen to him? Kids do not automatically know how to manage their anger; it is something they need to be taught. But at that moment I was having trouble managing my own. I knew there was only one thing I could do to change this situation.

I pulled up at Asda and went inside. As Mohammed was such a tall, well-built boy, there was no point shopping in the school-uniform section – there would be nothing there that would fit him – so instead I went to the adult sizes. Into my trolley went pairs of black trousers, a pack

of short-sleeved white shirts, two black jumpers and a black blazer. The cashier ran up £64 on the till and I paid with my own money.

Back at the school, I called Mohammed to my office and handed him the shopping bags. He was shocked.

'Miss, why did you do this for me?'

'Because I'm fed up of you getting in trouble,' I said. 'But there will be no more excuses. You've got the clothes now; the rest is up to you. I do not want to see you back in my office. Do you understand?'

I might have sounded harsh, but I needed him to preserve some dignity.

'Yes, miss,' he said.

'And I don't want you to tell anyone about this,' I said. 'Because I'm not going to.'

He shook his head, and I sensed his relief. Mohammed didn't want to be treated like a charity case any more than I wanted to treat him like one. I have not done that for a pupil since, but I felt so strongly that if someone did not break the cycle that this boy was repeating, then he would drown, metaphorically speaking. Sometimes all a kid needs is a break.

The following day, there was a knock on my office door. In the doorway stood a boy I barely recognised.

'Look at you,' I said, swivelling round in my chair as he walked in.

'I wanted to come and show you, miss,' he said.

Mohammed stood in front of me a changed boy. I scanned the length of him, a crisp white shirt and school tie, a clean blazer and ink-black slacks.

'Wow, Mohammed,' I said, 'you look amazing.'

'Thanks, miss,' he replied.

We never acknowledged that day again. We didn't need to. If Mohammed had been acting up to the image he had created for himself before, now he had a new one. Not just clean clothes, but a clean slate. It was rare after that for me to see Mohammed in my office. Instead I watched quietly from the edge of the dinner hall as he chatted with his peers.

'You look smart, bruv,' I heard one of the other boys tell him.

Mohammed kept his clothes clean. Other teachers couldn't believe the difference in him. They reported to me that he wasn't so disruptive, that he had started to produce good work. I played dumb, keeping my promise. He wasn't perfect, nobody is. But most of us know that sense of pride we have in our appearance if we make an effort. Why should it not be the same for our kids?

I learned to keep a stock of school uniforms in different sizes after that. Mohammed was far from the only student not dressed properly for school.

It isn't part of our role as teachers to dress our students, but we see the impact it makes on their attitude in general. Every single child who arrives at our school receives a tie, jumper and bag that is paid for out of the pupil premium

budget.* This ensures – from the outside at least – that pupils start on an equal footing with one another. It is our gift as a school, a welcome into our community, and a way of taking the burden of cost from some of our parents. In my experience, if pupils look smart, they act smart. Or, at least, it is one less thing for our kids with difficult enough lives already to worry about.

*The pupil premium is a grant the government gives to schools based on the number of students in that school on free school meals.

Three

My father didn't want me to attend the interview at Alperton. He had heard stories of a failing school in a 'bad area', with pupils who did little to improve the reputation of the place. He longed for me to work in a school that was better than the one I had attended. It's curious how we draw conclusions about schools so quickly, how we deem them bad or good – the Ofsted inspection system probably doesn't help – and perhaps once people have made their mind up about the school, the students live up to that reputation. It would be more helpful to focus on a school's potential, rather than its failings. Under the right head teacher after all, a 'good' school – the second-highest Ofsted judgement – can soon become 'outstanding'.

The first placement I had been assigned to as part of my teacher training was in a nice middle-class area in Stanmore, Middlesex. The area was home predominantly to hard-working Asian parents determined their children would succeed with opportunities they themselves had

been denied, so the children were perfectly behaved, there was little disruption in class, and homework was always handed in on time. It was easy. Too easy. A world away from the school I had attended; I felt out of place in such an affluent area.

The email informing me where I was going for my second training placement came through while I was still at the first. My mentors sucked in their breath when I told them which school I had been assigned next.

'It's very different,' was the only description they would commit to.

The drive to the second school was soothing. I left behind the concrete of north-west London and headed up the A41 into lush green spaces and leafy streets. A beautiful old Victorian building with tall sash windows, the school looked more like a traditional grammar, despite its reputation. It seemed to me that my former colleagues had been worried about nothing.

Inside the reception area, there were seven other trainee teachers waiting. We swapped tales of the schools where we had been already. We'd all attended different universities, and the training varied at each of them. I noticed many of the others were deep in the theory of teaching, yet made no mention of what was at the heart of it – the kids.

There are many people who enter the teacher-training system but not so many that emerge at the other end.

I remember during my very first lecture, our cohort leader explained that he only expected half as many seats filled by the end of the year. It made little sense to me then, so full of energy and enthusiasm – surely everyone knew what they were letting themselves in for? But perhaps I shouldn't have been so surprised. A 2012 study by the University of Buckingham revealed that a third of teacher trainees will not go on to work in the profession. Out of 38,000 teachers who trained in 2010/11, 70 per cent were still in their teaching posts by the following January, and only 61 per cent of those teachers worked in state schools. Perhaps having a sister in the profession had given me a more rounded impression of the ups and downs of a school day.

My mentor at the second placement was Edna, a warm, matronly woman who wore paisley-print shirts and Birkenstocks without socks in January. Close to retirement, her only advice for the lesson was: 'Keep them in the classroom.' I pressed her for more about the learning requirements, school policy, standards, but she waved my questions away with the same advice – that all I needed to do to succeed was to get through each lesson with a class intact. She gave me a tour of the school. The corridors were rowdy, with shouting and swearing, a haze of Impulse and Lynx scenting the air, punches thrown and threats made. Edna's warnings started to make sense. Expectations at this school were low. But what really stood out for me was the sea of white faces.

At my first placement I had been itching to get going in the classroom but I'd had to spend weeks observing. Here I was being thrown in at the deep end. I had been assigned a Year 11 GCSE graphics class.

'I've never taught graphics before,' I told Maria that evening. 'Let alone Year 11s.'

She promised me she would try and get some course material from her colleagues. Graphics was more of a design and technology subject than art. I figured I would need to learn on the job, alongside the students. But I found observing Edna's classes as uninspiring as the students seemed to. She handed out worksheets that had been photocopied so many times that the instructions on them were barely legible. Each pupil was expected to work on their own from the sheet, but instead their attention quickly waned and they chatted, feet up on desks, the boys passing around gum, the girls comparing their long acrylic nails. This wasn't teaching so much as babysitting. When it came to my turn, I was determined to engage them. I asked Edna if I could rearrange the layout of the room for my first teaching class. It seemed to me that the desks at the back were too far away to see the board. I printed individual workbooks, so the kids didn't need to strain to see a PowerPoint presentation: it would all be there in their hands for them to refer to. I wasn't sure if I had planned it correctly, but I knew this was my time to experiment, that anything was worth a try.

I showed Edna what I had spent three days over the weekend preparing – the graffiti worksheets, the laminated stencils, the greaseproof paper I'd bought from Tesco for the students to trace letters.

'Very good,' she said, though I got the sense she wondered why I had gone to so much effort. 'But just remember what I said.'

The following afternoon the students piled into class – ten minutes after the bell. They weren't wearing regulation uniforms like at my previous school, instead they had fashioned a type of their own: the girls sat behind their desks in white Puffa coats, fiddling with their hair, their fingers covered in sovereign rings, and they sighed as they checked already flawless make-up in compact mirrors. On the other side of the room, the boys chewed gum and left their shirts hanging out of their trousers, or, more often, black jeans. Many of them had glassy eyes, hooded lids and pupils that didn't quite focus. It appeared that most of the class were high.

One of the boys put his hand up: 'Miss, can I go to the toilet?'

He'd only been in the classroom a matter of minutes. He obviously wanted to go to the loo to smoke, or leave the school premises. I shook my head but he got up from his chair anyway. A moment later, another student followed him and headed for the door, then another, and another. I hurried towards the doorway, blocking

their path; this was going to be more difficult than I had anticipated. I pointed them all back at their empty chairs.

'Go and sit down,' I ordered them.

I'd planned to look at fonts for this lesson. From my bag I produced some magazines that I thought they'd find interesting: music, football, celebrities. I scattered them across their desks and they pounced on them, flicking through, reading titbits to each other, laughing at photographs. This wasn't what they were for. I told them I wanted them to look at the fonts and logos.

'What makes these magazines appealing to teenagers?' I asked them.

Blank faces stared back at me, but I pushed them to think harder, sowing seeds of thought in their heads until they understood better the reasons that they themselves enjoyed these magazines. We did some brainstorming, came up with ideas, I told them about a 'friend' of mine who was a graphic designer and how she always tried to appeal to the target market.

'What's a target market, miss?'

These kids were about to sit their GCSEs but they didn't even have a grasp of basic design and technology language. It wasn't just the staff who appeared to be treading water, but the students too, biding time until they got jobs locally. The magazines in front of them were proving to be distracting rather than inspiring, so I gathered them back up.

'What I'd like you to do is design your own font,' I said to them.

I went around the class, putting cartridge paper and pencils I'd brought from home on each desk. None of them moved.

'OK,' I said. 'Let's start with Harry, shall we? I'll show you what I mean.'

Carefully, I wrote his name in bubble writing. 'You'll need to use a ruler so each letter is the same height,' I explained. 'And you need to shade it in, to make it look 3D.'

I showed them what I'd done.

'Oh wow, miss, that's amazing,' they said, and then hands went up, requests for me to do the same with each name in class. Not what I'd had in mind, but at least it was a start. They were engaged. They started having a go then, the boys doing cloudy letters, the girls copying my bubble font. One boy was still asking for the toilet, but with one eye on the clock, knowing it was getting closer to the bell, I kept promising he could go after he'd drawn a few more letters. I whizzed between desks. It was like having to keep control of thirty terriers. I was grateful as the minute hand wound its way around the clock face, and there were only seconds left of class – I was exhausted.

'For your homework, I want you to design a graffiti tag of your name,' I shouted over the din. But as the bell went, they pulled on their coats, the scraping of tables and chairs rendered me inaudible, and in a second, they were gone, their worksheets and fonts drifting to the floor in their wake.

Edna arrived back in class to find me on my hands and knees picking up paper, pencils, rulers and rubbers. I looked at her differently this time. I admired her bravery. I could see how easy it might be to fall into a state of permanent exhaustion facing a class like that every day. I had no hopes of them doing their home-work. I could understand now how Edna had been forced to adjust her own expectations. Only bitter experience had taught her that, and that was something I knew nothing about.

By the time I was six years old I had my own school register, made up of teddy bears' names; it had pride of place in my bedroom. I played school with my cousin, Andrianna – she was the librarian and I was the teacher. My brother, Christopher, was on that register, alongside his fluffy peers with their glassy eyes and stitched-on noses. Four years younger than me, he was happy to tag along in whatever game I was playing and seemingly enjoyed being bossed around, so long as he was included. He sat alongside my toys at makeshift desks fashioned out of cushions. In front of each pupil was a book, which was swapped frequently on 'class trips' to the library – or more accurately, the box room next door.

Ten years later I would sit in my own GCSE art class, rearranging the tables and chairs with my mind's eye. One day, when I have my own art room, I told myself, I'll put all the materials in that corner, I'll have the displays

over by the window, and the desks in a horseshoe shape surrounding whatever project I'm demonstrating.

Even then I kept every worksheet that was handed out by my teacher, noting the ones that I found particularly inspiring.

By the time I was at university studying textiles, I had a first-year assistant who I would teach patiently how to thread the loom in my machine.

'You should be a teacher,' my assistant told me as I praised her when she got it down pat. I had been hearing this from people my whole life. By then it wasn't a case of if, it was a case of when.

There was no eureka moment when I decided to be a teacher; it was as if the idea was engraved into my bones from the very beginning – there was nothing else I would be. My parents never challenged my already made-up mind, not when our greatest Greek figureheads – Socrates, Aristotle and Plato – were teachers of philosophy and life. As far as they were concerned, a career as a teacher was a most respectable profession. My sister, Maria, had already graduated from teacher-training college by the time I started my degree. The idea of two teachers in the family made my parents proud, and they couldn't think of a more ideal profession for a woman.

'It means you can be on holiday at the same time as your children,' my mum told me when I first raised the idea that I would go into education. Those grandchildren of theirs did not exist yet, nor a father for them, yet

entwined alongside my career plans was always the idea that I would grow up to be a 'good Greek wife'.

Each evening my sister came home from school with stories of what the day had held for her. I ignored evening TV dramas in exchange for tales from her school day – loving the fact that no day was ever the same: there was the head of year she worked for who was so strict she terrified my sister, never mind the pupils; the rude parents and how she learned to deal with them; the children and the problems at home they felt safe enough to confide in her.

When I finished university, I got a job with a fashion house, but despite the fact that I spent all day surrounded by rich and sumptuous fabrics, they were no match for the colour of my sister's working day. I tired quickly of the monotony of an office: the same people, faces and places. I longed for the uncertainty of school life, the school bell, the classroom, the challenging behaviour and the breakthroughs. It was where I belonged.

The following week, in the school where I was doing placement, I was trying not to be swept away by the tide of pupils and their jostling in the corridors as they went between classes, when among the throng, I heard someone calling: 'Miss! Miss!'

I turned around and a skinny boy from the GCSE graphics class was catching up with me. He threw his rucksack down at my feet.

'I've got my homework, miss,' he said.

All around us students were passing, some knocking into him, but he was undeterred. From his bag he retrieved a torn bit of lined paper ripped from the back of his history book – the first two sentences written in spidery handwriting were about the Tudors. At the last school the kids' parents had been able to afford to buy them professional sketchbooks and their work was always perfectly presented, but this piece of homework was offered to me with no less pride. In the middle of the page, drawn in biro, was his name – Mikey – written in 3D-graffiti style, just as I'd requested. I could sense in his gesture that it wouldn't have been cool for him to have handed the work to me in front of everyone else.

'This is brilliant, Mikey,' I said. 'You've made my day.'

He beamed under his curly hair, his acned face blushing.

'Thanks, miss.'

I hurried back to the classroom. It wasn't long before the students would arrive, and I wanted to make Mikey's work look really special. I cut it into a nice square shape on the guillotine, losing his history notes to the blade, then blew it up on the photocopier to A3 size. I mounted it on black paper, and put it in pride of place in the centre of the wall, just in time for the students to start filtering into class – late, of course. They were paying no attention to me, cussing each other, swearing, slapping the back of each other's heads and talking about Arsenal

this and Tottenham that, but then one of them spotted Mikey's work.

'Woah, did you do that, bruv?' they asked him.

He looked over at the wall, pride spreading across his face.

'Yeah, I did, it was our homework, innit?'

I waited until they'd all had a chance to admire it, and then tried to tell them what we were doing that afternoon. My plan was to design an album cover, but suddenly the students had other ideas.

'Nah, miss, I want to do what Mikey did. Have you got those sheets you gave us the other day?'

'Yeah,' the others chorused. 'We want our tag on the wall, too.'

I abandoned my plan. These kids were enthused about their work, finally. Edna popped in halfway through the class and saw every single one of them, head down, concentrating on colouring in their own tag. She raised an eyebrow at me and I shrugged. At the end of the class we all stood back to admire their work on the wall around Mikey's. Even when the bell rang, they didn't rush out.

'What are we doing next week, miss?' they asked instead.

They even hung around to tuck in their chairs and put their materials away.

That was when I knew I had them. It had taken one boy to hand in his homework – and to have it treated as something worthy of respect – to give the rest of these students the incentive to aim for something similar. We

all want recognition, and kids are no different. These students had been forgotten about because they didn't fit into a one-size-fits-all approach. They needed a lesson specially constructed for them, for their likes and dislikes. Anything else would not get – and more importantly, keep – their attention. I learned from this school that it is not creating more work for yourself as a teacher to tailor lessons to engage individual classes. In fact, it can make your job easier, because if you can find a way to connect with students, that's where the real teaching begins.

The following week we sat around looking at CD covers and discussing their favourite rappers. Back then, I was only ten years older than these pupils, so I was granted special kudos for the fact I'd heard of the artists they were talking about. It was a great lesson – so much shared, so much learned. It was what I had become a teacher for. The lessons with this class became the ones I looked forward to more than any others. Students that were previously just staring at the clock, waiting for their time in school to be over, now saw that they had potential for something more.

After another eight or nine weeks we were putting together their GCSE portfolios, but my time at that school was coming to an end. One of the girls came up to me. I remembered her from the very beginning, more interested in the design on her nail gels than anything Edna was teaching. But I'd noticed how her work had changed. She had real talent.

'Miss, are you going to be here next year?' she asked, quietly. 'Because I'm thinking of staying on and doing A levels.'

I looked away from her, unsure what to say. All I could offer her was the truth.

'You must do A-level art next year,' I said. 'Because you're brilliant.'

The experience at the second placement school changed everything for me. It didn't matter that my dad didn't want me to attend the Alperton School interview – he had not seen that these were exactly the students that I wanted to teach. I wanted to be somewhere where I could make a difference.

'You always hear of fights at that school,' my dad tried. 'It's not a good place for you to go, it's not a nice area.'

But there was nothing he could say to dissuade me.

'I want some teaching experience under my belt,' I told him. 'It's very hard to get a job as an art teacher – vacancies very rarely come up. It'll only be for a year, and then I'll find something else. I promise.'

That seemed to put his mind at rest.

When we found out I had been shortlisted for an interview, Maria agreed to help me prepare. One of the things I needed to do was give a lesson that would be observed.

'What do they want you to teach?' Maria asked me.

I shrugged. 'They haven't told me.'

'Well, you need to ask. You need to find out what year group you'll be teaching. What is the seating plan in that classroom? What work have they done before your interview? You need to be prepared, Andria.'

I emailed the school, but the only answer that came back was that I would be teaching a class of Year 9s for one hour.

'Apparently I can teach them whatever I want,' I told Maria.

She screwed up her face. 'That doesn't sound good,' she said, her enthusiasm for this new opportunity waning. 'Perhaps Dad is right.'

'No,' I said, thinking of the graphic-design students. 'I can do this.'

Two weeks later I sat in the Alperton Community School car park at 8.57 a.m. I was due at nine o'clock and would have been half an hour earlier if I hadn't had to return home to collect the portfolio that I had left in my panic. My sister had spent the weekend rehearsing mock interviews with me, and in between times I had been putting the final touches to my portfolio and my lesson plan. I had beside me a bag of basic materials – paper, pencils, rulers, rubbers. Items that I knew for some underfunded schools were a luxury.

From the driver's seat of my car, I looked up at the tall building, noticing how many of the windows were broken, then picked up my materials and walked across the snowy playground towards the school.

Outside reception I glanced down at what once must have been a display of flowers, but now was just a cross-section of tyres overgrown with weeds and decorated with icicles. Inside, the reception area was not shielded from the soundtrack of school life – I looked around at my fellow candidates as we flinched at the sound of screams from down the hall and slams of doors loud enough to make us jump in our seats.

'They won't be long,' the receptionist assured us, with a smile that begged forgiveness.

We were soon gathered up from reception and taken to our various departments. I was shown to the door of the room I would be teaching in. I peered inside. It looked more like a dark, dingy cupboard under the stairs than a bright and airy classroom. There were huge windows – many panes fractured and broken – but the light was obscured by the sheer amount of dirt on them. The furniture was old and much of it was falling apart, and the displays on the wall had started to gather dust and cobwebs. The tables were organised in rows, which made it difficult to walk around, but the bell was about to go, and there wasn't enough time to do any heavy lifting or rearranging on my own. I would be taking my Year 9 class at the same time as another inter-viewee took one in the classroom opposite, and the teacher observing us would go between the two rooms. With that, I was left to await the sound of the bell that would signal the start of the lesson. I had no nerves in that moment, only excitement as I wandered around the room arranging my

material and handouts. I dared myself, in those few seconds before the bell was due to ring, to imagine what this classroom would look like if it was mine – I wondered how anybody, student or teacher, could find it a pleasant environment to spend each day in.

Minutes later I heard the sound of the bell and then the corridors started to fill with noise. I could hear screams and bustling, a rowdy rabble resembling closing time at the pub more than students arriving for a lesson. I glanced towards the ceiling, praying they weren't heading my way, but almost immediately this bullet train of a class came bursting into my room. Not that they seemed to notice me standing at the front; they bustled in with their big winter coats still on, shouting and swearing, and – I was horrified to see – tossing the odd snowball at one another.

'Excuse me?' I said, in a loud, clear voice.

No response.

Then, mustering my most authoritative voice from deep in my chest, I tried again: 'Can you please take your seats?'

This time, a few of them at least noticed me.

'You have ten seconds to take off your coats and sit down on your chairs,' I said, 'before I start writing names on the board. So. Ten… nine…'

I carried on counting, grateful to spot half the class starting to comply, the other half following shortly afterwards.

Once they were sitting down, I could see just how poorly designed the layout of the classroom was. There were too many bodies for one thing: students sat squashed

together, conscious of the elbows of the people next to them invading their space – how were they meant to do any learning like this? But there wasn't much I could do in that moment, so instead I started the class. Their task was to draw a portrait of the person sitting next to them.

'But the key is, you're not allowed to take your pencil off the paper once,' I said.

They looked around confused, and so I demonstrated. They seemed excited by all the abstract squiggles and keen to have a go. The only problem was the noise – I spent more of the lesson chastising them for chattering than teaching anything useful, no one could hear my instructions over the sound they were making. And the worst thing was, they weren't afraid to answer back.

'Miss, you're so rude,' they said, when I told them for the hundredth time to be quiet.

'I'm going to stop the class if you carry on talking when I'm speaking,' I answered back.

But they got into their work eventually, just in time for the teacher to observe them, heads down in concentration, the lead of their pencil scratching against the paper.

She nodded at me. 'You've got five minutes left,' she whispered.

I was relieved because I was exhausted from herding such a bunch of unruly teenagers. I had hoped perhaps that the GCSE graphics class I'd taught was a one-off, but this felt more like kindergarten. But I had to admit that when they did focus, what they produced was brilliant.

'Right, can you label your work and put it in your sketchbook,' I shouted over the din.

Blank faces stared back at me.

'Sketchbooks?' a few asked. 'What are they?'

I was surprised. Even in the last school I'd been at, all the kids had their own sketchbooks. When the bell went, most of the students went flying out the door, leaving behind a confetti-cloud of paper fluttering to the ground in their wake. Two Gujarati girls stayed back to help me pick things up and tuck the chairs in.

'Are you going to stay, miss?' one asked.

I took a deep breath, unsure whether I actually wanted to. These kids were out of control. After this I was due to have my interview, and I was already imagining what I would *like* to say: that the students were all over the place; that the school building itself was on its knees; that you would have to be mad to want a job in a place like this; that for all the gold in the world I wouldn't want to work here. That my dad might have been right.

I smiled at the two girls: 'I'll have a think about it,' I told them.

Later that afternoon the head teacher called to offer me the job. I was under no illusions that the school would be a hard place to work, that it would be a challenge. But it was a job.

I told myself it would only be a year, and I accepted it on the spot.

Four

When people think of teaching as a profession, they might think of all the holidays we get. Yet when my daughters were small, and were off school on holidays themselves, I would often take them into my classroom during half term or other holidays, and they would sit in the corner, up to their arms in paint, wearing an apron many sizes too big for them, while beside them GCSE and A-level students used the extra time to complete projects that wouldn't get finished otherwise. It wasn't unusual for me to give up half terms or end-of-term holidays.

For the most part, the students appreciate you giving up your holidays to keep classrooms open – it gives them access to the space, the equipment and all the materials, and of course, I was on hand to offer them help and guidance. One piece of work can take hours to perfect. It's why many children don't pick art at GCSE or A level, because they understand the amount of time that it demands. Some children, of course, just want the chance to see their friends during the holidays, and

there are also those who relish the opportunity to escape from a less than perfect home life. Research carried out by the Education Support Partnership in 2018 revealed that the number of days teachers expect to work over the holidays has increased from six days in 2013 to eight just five years later. For head teachers and senior leaders in schools that rises to eleven days. In a 2016 YouGov survey for *Tes*, a publication for education professionals, almost half of teachers expected to spend two weeks or more on schoolwork during their six-week summer break. Some schools recompense them with money or time in lieu, but that is extremely rare. For most of us, the priority is getting the children through their exams.

When I open the classroom in the holiday period, I always try to make it fun for them – and me. We listen to music, I provide snacks and we chat. The atmosphere is more informal, and they always love that they get to wear their own clothes rather than their uniforms.

Just like Brent, the borough of Camden, when I attended school there thirty years ago, was an extremely deprived area. My father was the priest in the church next door to the school, and after the service on Sunday it seemed as if all of Camden's homeless would gather as people filed out of church. As a child I found the smell of these people overwhelming. I stood well back from them, but my father would give them whatever he could from the church funds to help them get a meal or a bed for the night.

At school too, our teachers understood the power of small acts of generosity. It is, after all, often in the most testing of times or circumstances that you find the greatest gestures of kindness.

We were around seven or eight when Miss Matar came into class one morning clutching a bag heavy with jewels. She placed it down on one of the tables in the middle of the classroom and called all the girls over to have a look. She upturned it, and poured out treasure that twinkled under the strip lighting in our classroom. Her rings had always fascinated me, and here they all were; not only that, but bracelets and bangles, necklaces and brooches. There was silver and gold, burnished bronze and polished pewter, and set inside many metals were tiny glistening jewels in colours I had rarely seen in the classroom poster paints.

'I've been tidying my house,' Miss Matar explained, 'and I've found lots of things here that I don't need any more.'

I had often tried to conjure up what Miss Matar's house might be like from the clues in her clothing or the scents on her scarves as she wafted past in the classroom. I'd pictured some Aladdin's cave of antiques and rare gems, masks and crafts from her trips to Africa. I imagined walls painted in the same rich and earthy tones that she picked for the cushions in our reading area, rather than the plain white ones in my grandmother's flat. No, Miss Matar's home would be far more exotic, it would be filled

61

with the scent of spices and musk and she would drink mint or apple tea rather than Lipton's.

'Please take these,' Miss Matar urged us, pointing at the jewellery, 'they might be useful for dressing-up.'

We held our breath until we were sure she meant it, that she had really chosen us to bestow these treasures upon. Not her friends, or even her children, but us, her students. Tentatively at first, we started picking out the ones that caught our eyes. Every item had a story, and we listened fascinated to each one. Finally, I found among the pile a thick silver band held together with two circles of metal.

'I remember buying that in Africa,' Miss Matar said. 'It's one of my favourites.'

Africa was a continent I had only ever read about in books. I folded the ring into my palm and went to sit back down at my desk. The ring was too big for any of my fingers, but I put it on my index finger and kept checking throughout the day that it was still there. At home I showed my mum.

'She gave it to you?' she said. 'How nice.'

I found some string and wound it round the silver band to make it fit more snugly to my finger. Of all the school days that have been erased since, that memory has stayed with me.

I was nine or ten when we went on a school trip, not far, just to see a church in Kentish Town, a mile or two up the

road. We walked there one hot, sunny day in a long line, two teachers bookending us as we crossed the roads. Only on the way back, we took a detour through a local council estate and right up to the front door of the flat where our teacher Mrs Kinane lived. Mrs Kinane was older than the most teachers at our school; it felt like she had been there for a thousand years. She was a small, gentle, Irish Catholic woman with lines on her face and a pin-sharp memory for every relative of ours she had ever taught. That day she turned the key in her door, and one after the other, thirty children and two teachers filed into her tiny flat. We squeezed into the living room, pressed up against the sideboard, watched over by the religious effigies on the wall and framed black-and-white photographs of her relatives standing on lace doilies. We waited, our eyes wide, our voices a whisper, while in the kitchen she took from her freezer two tubs of soft vanilla ice cream. One at a time she served us a scoop each, in whatever container she could find among her pots and pans. We sat cross-legged on her living-room carpet – so tightly packed that our knees were touching – as we ate cool ice cream from bowls and glasses, mugs and plates. Even at that age I recognised the significance of Mrs Kinane's gesture, and I made a silent promise to myself that when it came to my turn I'd eat my ice cream with a fork if I needed to. When everyone was finished, trained well by my Greek grandmother, I got up and collected everyone's bowls, and asked Mrs Kinane if I could wash up for her.

'Oh no, no, no,' she said, and with that she started to gather us all up from the floor in time to return to school.

Today we have safeguarding measures, rules and regulations that mean teachers simply couldn't do that. Yet I had joined the education profession precisely to be a teacher like Miss Matar or Mrs Kinane – teachers who might have broken the rules, but in doing so, made us kids feel something no one else did. They made us feel special.

Chris Clarke was a student in Year 11 with his own special educational needs. He was also a brilliant basketball player. To Chris, every minute spent in the classroom must have felt like one taken away from the basketball court. In that world he was quick-thinking and nimble. He saw opportunities with the ball and he wouldn't hesitate to go for them. He was tall – well over six foot eight – and had to bend down to come through the doorway into my classroom, as if his body had grown itself into the shape it needed to live his dream. And that dream was not to be sitting in my lesson. In class he had serious cognitive delay: a sentence that would take any other student a few minutes to write would take Chris an hour. But he would write it beautifully. It was frustrating to watch because Chris was lazy, too. In the classroom he just switched off and sat there. He made no attempt to finish his projects or hand in his homework, and it was hard to witness because he had some talent. He was in Year 11 – about to sit his GCSE exam – and I was sure I could nudge him

up from an E grade to a D, if only he would put the time in to finish two more pieces of work. I lost count of the number of times that I would tell him this, all five foot nothing of me looking up at him, wagging my finger, telling him to pull his socks up and secure himself the best grade possible.

'I'm opening my classroom up next week during Easter,' I told him, 'and I want you to come in and finish those two pieces of work.'

'But miss, I need to play basketball.'

'No excuses,' I told him. In reality, I knew there was little chance of him swapping a basketball court for a classroom in the school holidays voluntarily. I needed to think creatively. I resorted to bribery.

'If you don't agree to come, I'll call your mother and make sure she brings you, and then I'll get her to sit next to you in class until you finish your work.'

Chris's face dropped. 'You wouldn't, miss.'

If I've learned one thing teaching children, it's that you never threaten to call their parents unless you mean it. But I had grown so frustrated with Chris, I didn't know what else to do. If I really had to call his mum and ask her to bring her son to school, if I had to ask her to sit and help him for the whole lesson, all just to get this boy a decent grade at GCSE, then I would. There was just one thing. I had never known another teacher who had dared to try something like this. I decided to speak to Chris's special educational needs co-ordinator.

'If you think it'll work, do it,' she said.

With Chris still refusing to attend the holiday intervention, I was left with no choice.

I called his mum. I had met her once or twice at parents' evenings. She was a lovely Caribbean mum, completely dedicated to the son she had brought up alone. They only had each other, and, like a lot of single mothers I have met, she had brought him up against the odds.

'Mrs Clarke, I need to ask you a favour,' I said. 'Your son is going to hate me for it, and he'll probably hate you too, but I need you to do something for me.'

'Anything,' she said. 'Anything that you think will help my son, Miss Zafirakou.'

And so I told her my plan.

The following week, my students filed into the art room during their holidays. I watched the door, waiting for Chris. But he was nowhere to be seen. A few minutes later, his mother walked in.

'Mrs Clarke, how lovely to see you,' I said, my arms stretched out to greet her. 'But where is Chris?'

'Oh, don't worry, he will be here,' she assured me.

The kids put their heads down, biting on their bottom lips. I heard a few of them whispering to each other, and then to me as I started going around the class.

'Miss, you are so rude,' they said.

'I don't care,' I told them. 'I've got to get Chris a grade.'

'But miss, you went there. You got Chris's mum to come in.'

None of them could believe I had taken such drastic action. And I didn't even know if it would work.

Half an hour later a familiar face bent under the doorframe and came into the room.

'Chris,' I said.

His face said it all. He was so angry with me, his face thunderous.

He came over to my desk.

'I can't believe you've done this to me, miss.'

'Chris,' I said. 'I don't care how much you hate me right now. I don't care how much I've embarrassed you – you are going to get those pages done, and as soon as you do, you can leave and I'll get out of your face. How's that?'

He said nothing, and walked over to the desk where his mum was sitting, waiting to be his assistant.

I went over and handed her a pair of scissors and some papers.

'Mum, if you could just cut these out for Chris and put them there for him, that would be great.'

'No problem, Miss Zafirakou,' she said.

Chris kept his head down.

I kept my eye on him during the class, this big tall boy, whose legs were so long that his knees touched the underside of his desk. He sat beside his mum for most of the day as she carefully and patiently cut out shapes for him to stick onto his work. When she had exhausted that role, she got up and started helping other children, then she rolled up her sleeves and asked if there were any

other jobs that needed doing. She cleaned all the sinks for me, washing out the paint palettes that the kids always leave filthy and speckled with colour. She made a brilliant assistant, and seemed to be enjoying her day. Chris kept his head down, focused on his project so that he could finish as soon as possible and get away from both me and his mum.

At the end of the day, Chris left without saying goodbye, but on his desk he left two pieces of work that would secure him a D.

Two years after that fateful day, I had a call from Mrs Clarke, asking if she and Chris could come and visit me at school. I was teaching a group of Year 7s when they arrived, Chris – as always – ducking his head to come into my classroom. The Year 7 kids stared up at this giant.

'Miss Zafirakou,' Mrs Clarke said. 'Chris has some special news that we wanted to share with you. He has won a scholarship to a big college in America to play basketball.'

'Oh my God, Chris,' I said, throwing my arms around this huge boy who had once been the bane of my life. 'Congratulations. What an achievement.'

'We wanted to thank you for everything you did for him,' Mrs Clarke said, her pride in her boy so obvious.

I looked at him standing there.

'Have you forgiven me, Chris?' I asked.

'Just about, miss,' he said, grinning.

I turned to the class, desperate to share his good news.

'Kids,' I said, 'this is Chris and he used to be one of my students, but now he's won a scholarship to go to America to be a basketball player.'

The classroom exploded into gasps and 'wows', and the scraping of chairs as a dozen young boys, just starting out in the school, rose from their seats, their workbooks in hand, and asked Chris for his autograph. He bent down to take a pen and patiently signed them. It was a beautiful moment.

'Yo blud,' I heard one of them say, trying to keep it cool, 'can you sign my book too?'

I had always understood Chris's desire to be a basketball player, and I knew he had the talent to achieve that, but he needed to learn other skills too: discipline, dedication, tenacity and hard work. All of these skills were also necessary to get him that place at an American college. What we teach is not always just about developing kids in our particular subject area, it's also about equipping them with skills that can help them in so many other areas of their lives.

Teachers have an increasing workload, as outlined at the very beginning of this chapter, and I was often called upon to deal with particularly disruptive pupils. Liam Amir was one of these. I had been a teacher for three years when I was promoted to head of Year 9. It is possible to rise through the ranks as a teacher by taking on extra responsibilities, and those responsibilities tend to

fall into two camps – curriculum (head or deputy head of department) or pastoral (head or deputy head of year). Each role increases a teacher's pay grade, but reduces teaching time in the classroom. The load of responsibility increases exponentially.

For me, there was never any question that I wanted to be promoted on the pastoral side – it meant less time dealing with teachers and more time dealing with kids. But still, I was unprepared for the types of problems and stories that I would encounter. A head of year is responsible for every single child in that year and their performance. As well as this, you have to coordinate any school trips they will go on, deal with parent consultations, social services, and if necessary, the police, doctors and other professionals. Being a head of year gives you access to much more personal information about a child. At Alperton, this is information we need to keep confidential, even from their teachers. As a result, heads of year often carry a burden of information.

Liam was a mousy-haired boy of average height, though slightly larger than many of our students. He was scruffy-looking, but that's the way he liked it; his shirt was never tucked in, his tie was too short and always askew. Unlike some of the other disruptive students, Liam didn't have any special educational needs. Some children have a unique skill for exploiting vulnerabilities in teachers, and Liam was one of them. A teacher that he particularly seemed to target was Miss Kowalski. I had lost count of

the number of times that Miss Kowalski had come to me with her head in her hands asking for help in dealing with Liam. It wasn't only in her class that he played up, but it was always in her class. If she asked him to do anything, he refused. If she disciplined him as a result, he accused her of picking on him, and then accused her of being racist. As a teacher you never wish harm on your students, and yet there are moments when, just like in those Looney Tunes cartoons, you wish that a giant one-hundred-ton Acme anvil would drop from the sky onto their heads at the exact moment that they are disrupting the entire class. And Liam was doing just that. The other students knew that it was impossible for them to get on with their own work when he was acting up, standing in the middle of the room, arguing, and accusing his teacher of bullying him, when all the teacher had asked him to do was sit down and get on with his work like everybody else. I have taught these pupils myself, and it is incredibly frustrating. But Miss Kowalski was at her wits' end. It was time to call the parents. Only, when I called Mr Amir, he was completely baffled.

'Is there anything going on at home that we should know about, Mr Amir?' I asked. 'Because Liam is unusually aggressive to his teachers.'

There was silence at first on the end of the phone. I have dealt with enough parents to know that most mums and dads will deny that their child is any sort of problem. But Mr Amir was adamant.

'Miss Zafirakou,' he said, 'I just cannot believe what you are telling me.'

'I see,' I said. 'Well, please can you come into the school and see your son here?'

'When would you like me to come?'

We decided that we would keep it just between ourselves, but I checked Liam's timetable and arranged Mr Amir's visit to coincide with one of his English lessons.

The following week, Mr Amir arrived at the school. When I met him in reception, I got the sense that he was unsure what he was doing there, but he agreed that we'd have a wander up to the English department and he could observe Liam in class.

'After you,' I said, as I opened the door into the English corridor and, as if on cue, we were met by pandemonium coming from one classroom in particular. I saw the recognition appear on Mr Amir's face, yet he said nothing, perhaps still convinced the voice we could hear raging up through the corridor could not possibly be his son's. Only as we got nearer did I see that last hope begin to leave him. We walked past the window to the classroom, and sure enough, Liam Amir was on his feet in the middle of the class, his coat still on, his bag on top of the desk, berating his poor teacher, who already looked exhausted, despite the fact her class had begun barely ten minutes before.

'You're so rude, miss. How dare you speak to me like that?'

That was Liam.

We walked slowly past the window into the class-room. Mr Amir didn't say a word; he just stopped still, and looked through the glass at his angry son. In that moment, he saw what we did every week: the fatigue written large, not just on the teacher's face, but on every single one of the pupils; the class in disarray all because of one pupil; the other children losing attention quickly as they thumbed the corners of their own workbooks; his teacher with her hands on her hips, desperately trying to calm this tornado of anger that stood before her. Still Mr Amir didn't speak. He just stared inside the classroom, and then I watched a miracle occur. Liam turned towards the door and saw his father standing on the other side of the glass. As if the second hand of the clock on the wall had slowed, I watched his face drop; he slumped down into his chair, and without uttering a single word, got his books out of his bag and put them on the table, rearranging himself in an instant into the most studious boy. And then he sat there, frozen in shock.

As if mimicking him, Miss Kowalski stared back at him with a similar expression, as if she was wondering what on earth had instantly calmed the storm inside this boy. Unlike Liam, she had yet to spot us standing at the door. I took my cue. I opened the door and the whole class turned to face me and Mr Amir – all of them except his son.

'Hello Miss Kowalski,' I said breezily. 'We have a visitor here with us today. Mr Amir has just come to see how Liam is getting on in your class. How is he doing?'

'Well, er...'

For a moment she looked from us to Liam, still sitting, staring straight ahead, his book already open on the correct page. Every student around him sat on the edge of their seats, waiting to see what would happen next. Some at the back were already sniggering.

Miss Kowalski took a breath. 'Well, nice to see you Mr Amir. What can I say about Liam? Today he seems a little better and I'm hoping he'll focus a little more than when he came into the lesson. What do you think, Liam? Are you going to focus?'

Liam turned and looked at me, then gave Miss Kowalski a quick nod. At the back of the classroom a group of other kids giggled into their school jumpers.

'Thank you, Miss Kowalski. We'll leave you to it.'

I closed the door and led Mr Amir back down the corridor. He was still silent, but his jaw was tense, a thick pulse point pounding at his temple.

Bringing Liam Amir's dad into school was one of the most humiliating things I could have done to that boy, but it was a last resort. In a class size of twenty-eight, we can't afford to have twenty-seven other children disrupted all because of one.

'You're my hero,' Miss Kowalski said after school in my office.

'If you ever have any problems with Liam again, let me know.'

But Liam was as good as gold after that. We never had to ring Mr Amir again.

Some children, like Liam, demand your attention simply because of their behaviour. Other kids try their very best to go below your radar – and they are usually the ones that need help the most. Leroy Williams didn't have a proper school bag: he carried his possessions around in a plastic JD Sports bag. He had a modest selection of items: a pencil, a ruler, his football and some football boots. That bag also doubled as a pillow as he slept through his detention, and he received many of them. Almost every day after school it was just the two of us in my form room. Back then the school gave a forty-minute detention after school for students who were late for the register in the mornings. That meant for most of the week, Leroy's school day stretched past home time to 4 p.m.

One particular day, I walked over to him sleeping through detention and shook him gently by the arm. He didn't stir.

'Leroy?' I said.

Nothing.

I tried again, shaking him a little harder, calling his name a little more loudly.

He finally blinked awake.

'Sorry, miss,' he said.

I perched myself on the edge of his desk.

'What's going on, Leroy?' I asked. 'I mean, I love having you here, but every day it's just the two of us, and I have things to do as well.'

'I know, miss,' he said.

'Why are you late to school every day?' I asked. 'Can you tell me?'

'Oh miss,' he said, 'I just got up late – my alarm clock didn't go off.'

'We had this last week…' I said.

'I know, miss, but I was up late last night. I just didn't hear it.'

It was obvious to me that he was lying but there wasn't much I could do. We had, of course, tried calling home numerous times, but we had never been able to get hold of Leroy's mother. If I mentioned her to Leroy, he was instantly protective, promising to try harder to arrive on time. And that was the thing about Leroy: he was such a sweet boy, so likeable, with a stunning and persuasive smile – you couldn't help but believe that he would try to keep his word.

And he always did for a while – a few days would go by, enough time to dissuade you from another call home. Then Leroy would slip back into his usual pattern. Most kids get aggressive when you ask them why they were late for school. The usual answer will be a dismissive: 'It's not my fault.' But Leroy wasn't like that: he squarely put the blame on himself. Too much, perhaps. I went to check his file.

'He transferred here from the local primary,' the admissions assistant told me. 'We don't seem to have any of his official documents, but all the other paperwork is in order.'

Leroy was a Year 7 student at that time, part of the class that had started with me during my own first year at Alperton. His sister Samantha was in Year 11, and skinny as a twig, the same as him. But despite his size, Leroy was a brilliant athlete, the Usain Bolt of the playground, a Lionel Messi on the pitch. That tattered football he carried around with him was his prize possession – as well as being his pillow inside his plastic bag during detention.

As far as I was aware, his mother was a single parent, although I never saw her. When I called home I eventually got Samantha and told her I was concerned about her brother.

'OK, I'll speak to Mum when I see her at the weekend,' she said.

I stared down the receiver, confused. 'But it's Monday,' I said, 'why would you not see her until the weekend?'

'Oh, she's a nurse, miss, she works night shift.'

Of course she did. It was a reality for a lot of our poorer students that their parents worked night shifts, because they paid more money. I knew that Leroy lived on one of the most run-down council estates that surrounded the school, and it was obvious from the clothes he wore that there was not a lot of money to go around. When the rest of the pupils started a new term, they looked

smart in newly purchased uniforms. In contrast, Leroy's clothes were already threadbare, his Wallabees so worn that the soles flapped wildly when he walked, as if the moccasins themselves could talk – and what might they say about his home life, especially when he handed in his art homework on toilet paper?

'It was either that or a McDonald's bag, miss,' Leroy said, shrugging.

'That's OK,' I told him. 'It shows you are resourceful as well as creative.'

Inside, though, I swallowed down the shock once again, that for some children even paper and pens are a luxury.

Once, during break time, Leroy came rushing into my art room close to tears.

'My trousers, miss,' he said. 'I ripped them playing football.'

His panic was because they were his only pair. I quickly repaired them on my sewing machine. After that, I'd often have a queue of boys in my room at break time, asking me to repair rips or split seams.

At the start of the following year, Leroy arrived along with his form class – all of them in smart new gear. But I noticed Leroy was still wearing the clothes he'd had at the end of summer – even his shoes hadn't been replaced. And, as the school year went on, although he was a brilliant athlete, he kept getting detention for forgetting his PE kit.

'What's happening with your PE kit, Leroy?' I asked.

'Oh miss, I just forgot it again,' he said, and grinned, giving himself a mock tap on the head as if that might help to knock some sense into him. Yet for one reason or another, Leroy's school day always extended longer than his peers' through detention.

'It's fine, miss, I don't mind,' he said, whenever I tried to speak to him about it.

But eventually I decided enough was enough.

'Leroy,' I said, 'do you actually have a PE kit?'

He looked down at his worn shoes.

'Because if you don't, it doesn't matter, but just tell me, because it's not fair that you keep getting punished for something you can't help.'

He blushed, embarrassed, and I had my answer.

I went to see the PE teacher and asked if I could raid his lost property. Between us we found a red shirt and black tracksuit bottoms that we were sure would fit him. I took them home and put them through my washing machine, and then wrote Leroy's name inside them.

I didn't want to make a big deal of it in case it embarrassed him, but the next time I saw him, I casually handed him a plastic bag with the freshly pressed clothes inside.

'Some spares until your mum gets round to buying you some,' I told him.

I turned quickly and walked away, so he didn't feel he had to say anything.

The school year passed somehow, my form year extending up as they grew out of their clothes and into new ones. But when they all started Year 9, fresh and smart, ready for a new school year, my heart sank when Leroy reappeared in the same old uniform – right down to the same worn-out shoes. Not only that, but it was filthy, and with hormones raging inside him, Leroy had started to smell. The white collars of the one short-sleeved shirt he wore year in, year out were black with dirt. The cuffs of his school jumper were worn away, the threads unravelled, and his trousers were sitting an inch above his ankles. But worse still, the other students had started to comment on his appearance and his smell.

'Haven't you heard of those things called launderettes?' some of the older boys teased as they passed him in the corridor.

'Shut up, bro,' Leroy said, brushing off their digs with bravado.

His real friends were as loyal as always; they never mentioned the stench when he sat alongside them. I noticed too how sometimes they pushed lunch money across the desk towards him, or let him steal from their plates in the dinner hall – as if he were a seagull scavenging for a spare chip.

'Are you not having any lunch of your own?' I said to Leroy on the occasions I noticed.

'Oh miss, I had a big breakfast,' he said, patting his tiny stomach.

I wasn't convinced. More and more, I found myself buying two pastries in the morning and slipping one into Leroy's hand when he came in for registration.

'The chef had leftovers, so he gave me one extra,' I lied to him, and he accepted without question, a knowing look passing between us. (One of my biggest tips for new teachers is to make friends with the school chef – they will always look after you or, more importantly, the students, if you do.)

But the state of Leroy's uniform remained a problem. Eventually I knew that if his mother wasn't going to do anything about it, I'd have to step in. The following week I checked his timetable. He had PE last period on a Tuesday, so after the students got into their PE kits, I ran down to the changing rooms.

'Everything OK?' the PE teacher said, as he ushered the last boys out of the changing room.

'Yes. Can you just show me where Leroy's uniform is?' I said.

He nodded, knowing exactly what I was up to, and showed me to Leroy's peg.

'It'll be back by the end of the class, I promise.'

I raced back up to the home-economics department, where I knew they had washing machines, and put it on a fifteen-minute cycle. I stood chewing my nails, willing it to finish.

'You go and get on with your work,' the home-economics assistant said. 'I'll make sure it goes straight in the dryer.'

I got it folded and back into Leroy's plastic school bag with seconds to spare before the students arrived back from the school field.

Leroy had detention that night, and from the opposite end of the room, I saw him lift his arm to his face and give his jumper a sniff every now and then.

'Miss,' he said, 'what happened to my clothes?'

I bit my lip, not wanting to embarrass him. 'Well, I had a washing load to do myself,' I said, hoping one white lie wouldn't matter. 'And I was worried about you, Leroy. Personal hygiene is really important, especially when you're a young man and you have girls looking at you.'

He blushed.

'I hope you don't mind,' I said.

'No, miss. It's no problem.'

Every couple of weeks I did the same, washing his clothes while he was doing PE and returning them within the same hour period. But if anything, washing the clothes made them fray even further. I raided the school's lost-property cupboard and found him a new set of uniform. I washed everything at home, and labelled it just like I had the PE kit, so he would know it was his. The next time I washed his uniform, I left the bag of new things under his shoes.

That afternoon, he turned up at detention looking better than I'd ever seen him.

'You're looking very smart, Leroy,' I teased him.

'Miss!' he said, smiling.

'If anything doesn't fit, let me know, but we were going to chuck it all away anyway.'

'I don't mind, miss,' he said, 'I'm used to second-hand things.'

Students like Leroy are thankfully few and far between. This all occurred more than thirteen years ago now, in my very first years of teaching. Over the years, as a school, we have made many interventions when we feel that pupils are not being clothed in the required way. At one point so many children were coming to school in trainers that Annette and I went to a local shoe shop and bought as many leather-soled school shoes in as many different sizes as we could to keep in the year room. Pupils would come in every morning, swap their battered trainers for more sensible footwear and come back at the end of the day to swap them over again. That worked until we realised that we had to sit in an office with thirty pairs of stinking trainers all day.

There is a fine line, though, between supporting a student who is living in obvious poverty and when that becomes a case of neglect. When I did my PGCE (post-graduate certificate in education), I don't believe we had enough training on safeguarding protocol, and yet it makes up the bulk of our school day. Today a case

like Leroy's would be immediately flagged up to social services.

Over the last decade teachers have become the front line in terms of raising safeguarding concerns, but that hasn't been reflected in the training they receive to spot it. As with many things, we rely on instinct.

In 2017, a freedom of information request made by the National Society for the Prevention of Cruelty to Children (NSPCC) found that PGCE students received, on average, less than eight hours of safeguarding training over a course that lasted a year. One teacher told researchers that while studying for their PGCE at York University, they received just one afternoon's training on safeguarding. Yet once they enter the workplace, the responsibility for a child's safety often falls on the teacher.

In 2018 the Association of Directors of Children's Services (ADCS) revealed that an estimated 2.4 million initial contacts were made to children's social care in 2017/18 – a 78 per cent increase in a period of ten years. Abuse and neglect were the primary reasons for concerns about children. The majority of these referrals will have been made by concerned teachers, as became obvious during the COVID-19 lockdown in 2020, when child-protection referrals plummeted by more than 50 per cent in some areas of England. Without children attending schools each day so teachers can check on their welfare, little was known about the conditions in which they were living.

As for Leroy, in Year 11 he sat in our office – incredibly – wearing the same shoes that he wore on his very first day at Alperton Community School in Year 7. We'd had little to no contact with his mother in all of those years. I remember Annette asking a question that elicited a strange response in Leroy. She asked him if, legally, he was meant to be in the school. He just looked down at those very same worn-out shoes.

Perhaps Leroy's family were illegal immigrants. Was that why he had tried so hard over the years to protect his mother? To take all the blame and responsibility for his shortcomings on his own young shoulders? He knew that the less the school was involved with his family the better, so it meant that being on Brent Council's register and asking for help with free school meals was not possible for Leroy. Instead he had to go hungry.

By the time he left school, we still knew very little about Leroy's home life.

We all have our own idea of what normal is. For kids, normal is whatever their home life comprises. It is not unusual to see students who are going without at my school. Coats are a luxury any time of year. The blazers that we provide as a school are often the only shelter these kids have from the cold. In the winter months, when I pull into the school gates at 7.45 a.m., there will already be a long line of pupils waiting to get in, and

when they do, there is a scramble to the nearest radiator, where they linger until the start of lessons to warm their frozen bones.

It's the same with shoes: they are an expense that many parents just can't prioritise. It is not unusual for parents to pack their children's shoes out with newspaper to make them fit if they inherit a pair a few sizes too big. Teaching at my school, you get used to the sight of one of the boys kicking a football in the playground at break time and seeing a scrunched-up piece of newspaper come flying out of their oversized shoes.

I have been in students' homes and seen the poverty for myself. In the first few years of teaching at Alperton, I lived nearby and would often bump into my students on the high street on a Saturday. They always got excited seeing me in my 'civilian' clothing. More than once I was ushered a few streets back from the high street into the home of one of my students. Inside I saw how four or five families shared a house, the rota they made to take turns cooking in the kitchen, mostly being allocated one or two hours to cook the whole day's food, and then stacking it up in Tupperware on areas of the worktop assigned to them.

Once I noticed that one of my Year 10 GCSE students, Akila Desai, was skipping my art class. I was surprised – she was a quiet and diligent pupil. Yet in period three when I called the register, weeks went by when she was absent.

'She's probably bunking off, miss,' one of the other students said.

But that didn't make sense; she was a model student in all other departments. I felt a little insulted that it was my class she was skipping.

I went to see the pastoral assistant for Year 10 and told him what I was noticing. He sent a round robin to all of her teachers to monitor her attendance, and a week later I checked back with him to find out what was going on.

'You were right to raise the alarm,' he said. 'She was coming into school each morning but then leaving the premises without permission during periods three and four.'

'But why?' I asked. It just wasn't in keeping with her general behaviour.

He shrugged. 'Anyway, we've put a stop to it.'

The following week, Akila did arrive for my art lesson. At the end, I asked if she could stay behind, on the pretence of giving her extra work to help her catch up.

'Is everything OK, Akila?' I asked. 'Are you finding my class hard, or boring – is it not interesting you?'

She looked shocked.

'No, miss, nothing like that. I like art. I like you. I'm really sorry.'

'So what's going on, then?' I asked. 'Why have you been leaving the school without permission?'

'I have to be home then,' she said, 'because the cooking time for my family is eleven a.m.'

I realised then exactly what was going on. Like many families, hers had a rota system for using the kitchen to cook the whole day's food. With her parents at work, it was Akila who had to go home and cook for everyone, otherwise they'd have nothing to eat.

'So what's happened now?' I asked.

'My parents had a meeting with the school,' she said, 'they've tried to organise the rota differently so I can be in my lessons.'

It was shocking to hear, but I had some idea from my own background how duty can fall on daughters. But it isn't just girls who bear the brunt of this responsibility. All too often children of both sexes have to rush from school at 3.20 p.m. to go and pick up their younger siblings from local primary schools, or get home to care for elderly relatives – or parents affected by alcohol and drug abuse – dispensing medication, washing, cleaning and dressing them. For those students there is no opportunity to go out on their bikes after school or be part of a football club. Some even have jobs in corner shops stacking shelves to help support the family financially. Childhood itself is a luxury for kids like that.

I have seen the job change so much over the last four-teen years. Attempting to interpret the Ofsted framework has left many teachers with a feeling that nothing is ever good enough, that however hard they work, they will never catch up. The marking is constant and therefore

the hours increase. I can guarantee that at Alperton, if we weren't thrown out of the school at 6.30 each evening, many of us would be there until 10 p.m. marking, or catching up with paperwork or lesson plans. Instead, we take our work home. My husband, John, has never seen me not working in the evening, or answering emails from other teachers or heads of departments well into the night. There have been times when he's trying to sleep in bed and I'm still tapping away on the laptop, emailing my colleagues. I remember him turning over once, and asking: 'Why are you still working?'

It was typical of me and I thought nothing of it, only that it showed my dedication to the job.

'I'm just emailing my manager,' I said.

'But you're setting an example that you can be contacted at any time,' he told me. 'This is your family time – turn off your laptop and go to sleep.'

He was absolutely right, and it's something that I warn other teachers about – but even as I tell new teachers of the risks of burning out in the job, I know that it's often my husband who needs to remind me. A 2017 YouGov survey commissioned by the Education Support Partnership revealed that 47 per cent of teachers said their personal relationships suffered as a result of poor work–life balance. This is a reality for teachers. There is so much expectation piled on to teachers to look after other people's children – quite naturally – but some-times with stress and long hours, it can feel as if our

own children are overlooked, particularly when 76 per cent of teaching staff is made up of females. As with any industry, the work–life balance is dictated by the attitude of the leadership.

Going above and beyond our job descriptions to care for and protect our students makes up the majority of our workload as teachers, and yet it is not captured in any data that the government request from schools. Ministers focus solely on results in the sphere of learning – which would be considerably higher if our jobs only revolved around what happened inside the classroom, but that isn't the reality for many of us. Without taking into account all the other facets that make up our working day, our workload is increased year on year, and our time is stretched beyond basic teaching. It is perhaps no wonder that, according to a 2019 YouGov survey, three-quarters of teachers in Britain say the work–life balance is worse than they had imagined. When asked what put them off recommending the job to young people, 93 per cent of teachers said the large workload and 84 per cent cited the long hours.

So why do we do it? For many of us, we do not see teaching as a job but instead as a way of life, a vocation that is built into our DNA. We teach because we have to, because there is nothing else we would rather do. It is hard to put into words that golden moment when you see a light flicker on behind the eyes of the student who has been struggling to understand a concept for weeks,

or the student who softens after months of putting on a hard exterior. Yet these are the moments that make everything else worthwhile. There is no feeling like it, to know that you have made a difference, that you have inspired a young person to do or be better. That, for us, is everything.

Five

Alex Hopper was a boy who could never sit still in class. His was also the name that every teacher searched their register for at the beginning of a new school year.

'Oh no, I've got Alex Hopper in my class,' you'd hear.

'Good luck with that,' another teacher who had just finished a year with him would say.

He was a boy with special educational needs, severely dyslexic, and by the age of twelve he was still unable to read or write. He was white British – perhaps being a minority in our school didn't help – and his home life sounded chaotic. He lived in a small house on a council estate with a large assortment of pets: nine rats, two tortoises, three gerbils and enough cats to outnumber them all. But it was his aggressive behaviour that was so hard to control. He thought nothing of swearing at teachers or picking up a chair and throwing it across the room. His classmates were endlessly patient with him. They tolerated his outbursts. He had no friends, but the other students always said hello to him, asked him how

he was – even if he rarely gave them any response. When the sound of his anger rang out in class, they winced but carried on with their work – unlike Alex, who never did any. He was the same across every subject: his mood did not discriminate. We made endless calls home to his mum, and at first she put the phone down on us, until eventually she stopped picking up at all.

In Year 8 it was my turn to teach Alex. Keeping him in the classroom was the biggest challenge, although sometimes he was such a health-and-safety risk to the other children that it was better just to let him leave.

One particular day I was teaching the students about cubism, and we were looking at paintings by Picasso. The students were having a go at painting their own cubist portraits. I often pause the lesson to give kids a chance to look at each other's work and critique it, offering suggestions of what their fellow classmate could do next, or what's missing from the painting – it's a great way of gauging how much they understand technique and helps them develop a critical eye. At the end of the class, as usual, I gathered all the paintings up, but one in particular slipped out of the pile. It was as if Picasso himself were a student at our school. I turned it over, but there was no name on the back. I sighed and waved it over my head.

'Let's have a look at this piece,' I said to the students. 'What do you think of this person's work?'

The kids gasped when they saw it. A wave of 'wow's crossed the room towards me. I decided to start them off.

'I like the way the paint is mixed,' I said. 'It is the perfect consistency. Has anyone else got any feedback?'

A hand went up. 'I like the background, miss.'

Another: 'I like the design, it's really unique.'

Another: 'I think it's brilliant.'

'Wow, OK,' I said. 'It is great, but whose work is this?'

I saw an arm go up, right at the back of the room. I searched to see who it belonged to and, as the students parted their heads, I was astonished to find Alex on the end of it. The shock was apparent on my face, and all the kids turned quickly to see why.

'Alex?' I said. 'Is this yours?'

He nodded.

The entire class burst into applause. It took a moment for it to register on Alex's face – that the applause was for him – and then the smile spread across it.

I was almost too choked up to speak. I cleared my throat: 'This is so beautiful, Alex. Can you remember all the comments everyone made?'

He nodded, still smiling. 'Yes, miss.'

'But please, put your name on the back of your work next time.'

From that day something was transformed in Alex. He would be the first in line to come into my lesson. He would arrive early, helping me to hand out sketchbooks. He was more engaged, calmer too. Even his maths teacher, who had him the period before me, commented on how his work had improved. It was as

if, for the first time in his life, he had felt that he was as good as any other kid. He was celebrated, and it was a real celebration because no one that day had known that it was his work. Their compliments had been genuine, and the ripple effect of that changed Alex's life in the school.

A couple of months later though, the old Alex came creeping back. He came into class after lunchtime, agitated, unable to concentrate.

'Come on, Alex,' I called from my desk, chivvying him along. 'Get on with your work.'

He stood up from his chair then, his face twisted in an angry expression I hadn't seen in a long time.

'Shut up you fat cow,' he shouted at me.

Then he marched towards my desk, his fists clenched.

'This work is shit. I hate you. I hate you.'

And then he stormed out of the class. There was silence in his wake. I was aware of every child's eyes on me. I looked back at them, unsure whether that had really happened, but knowing I had to say something to break the silence.

'It's OK guys,' I said. 'I'm OK. We know what he can be like sometimes, just carry on with your work.'

I sent a quick message to the head of year, just to let him know what had happened. He came rushing into my classroom.

'What happened? Alex loves your class.'

'I know,' I said, shrugging.

The security guards eventually caught up with Alex. It turned out he'd had a few bad periods before he'd reached my classroom, and he'd only just held it together by the time he got to me. Like many of us, a child can be a pressure cooker, fit to burst if tipped over the edge. He was sanctioned for his behaviour, but when he was allowed to return to class, he came up to me one lunchtime.

'Miss, I'm really sorry for saying those horrible things to you,' he said, wiping his eyes on his jumper.

I reached out to him. 'You don't have to apologise, Alex. We all have bad days… but am I really fat?'

We both laughed.

Alex's school life changed because of the appreciation he received in art class. It's incredible that with everything that he had to deal with in his life, it took that one moment of recognition to give him a good reason to turn his life around. If there is one lesson that I learn over and over in school, it is that all any of us need once in a while is someone to really believe in us.

Dealing with students like Alex is par for the course on an average teaching day. Often, those with behavioural issues see life through an entirely different lens from the rest of us. It's no wonder that there can be misunderstandings or communication problems. But at least we had the ease of speaking the same language. It must be so much more frustrating for our students who cannot speak

English – I know it is for me when there is so much I'd like to communicate to them, so many ways I would like to help engage them in their learning.

Our school had high student mobility. It meant that there wasn't the consistency of students entering in Year 7 and leaving in Year 11. They might enter midway through the year and leave weeks later. It means their education is not solid, they have probably missed a lot of learning, and their predicted low grades can adversely affect our results as a school. But there are also a lot of EAL kids – those for whom English is an additional language – who come to us with all their stories and trauma, much of which they cannot express, and who far exceed anyone's hopes and aspirations for them.

Kalindee Shah was one of those students. She arrived in my classroom timid and shy, unable to speak a single word of English. Kalindee had come to this country from an island off the coast of India called Diu. We have had a few children who have arrived from this island – it was a Portuguese colony until 1961, and so it's easier to migrate to Europe from there. Many of these students at Alperton haven't received a formal education before: instead they have often been raised working alongside their parents in homes or on farms, and educated on the streets by their peers. Their grasp of their own language is crude and they use a lot of slang, and they go around teasing and hitting other kids, but they have a confidence about

them. They are streetwise, as canny as Charles Dickens's Artful Dodger. Kalindee had been buddied up with another girl in class who spoke Gujarati, and, as a result, all of our communication needed to go through her. The first time she walked into my classroom, I welcomed her with the few words of Gujarati that I had taught myself. Then I handed her a worksheet.

'Draw what you can from here,' I said, 'and I will come and see you in a few minutes.'

I waited for her buddy to translate.

'OK?' I said.

Kalindee nodded.

I walked around the class, checking up on her, but it was hard to make her feel really welcome when I had to go through a translator each time. At the end of the class I gave everyone homework – to draw someone who inspired them.

'You can draw anyone: a celebrity, someone you know…'

Above the din I could already hear the boys planning which of their favourite footballers they would sketch. Whenever I set homework like this, I get a pile of Beyoncés or footballers and cricketers back.

Kalindee's buddy came up to me.

'Miss, can we get some paper and borrow some stuff for Kalindee?'

'Of course,' I said, pulling a plastic food bag from my drawer and filling it with paper torn from a sketchbook and some oil pastels.

'Do you understand?' I asked Kalindee again. 'Draw whoever you like. Priyanka Chopra?'

The girls giggled at the mention of an actress I knew they loved.

The following morning at 8.30 a.m. I arrived at my classroom. Kalindee was waiting there alone. She looked tiny standing in the doorway, just four feet of her – far smaller and skinnier than her peers.

'Hello Kalindee,' I said, 'how are you?'

But she only stared at me blankly.

With tiny, bird-like hands, she pulled from her bag a piece of paper and handed it to me. I opened it, and inside, the most amazing drawing of a child staring into the distance greeted me. I gasped as I took it in; a perfectly captured empty gaze, every contour of the face brilliantly shaded and toned. I looked at her.

'Is this yours?' I said. 'Did you do this?'

She had no idea what I was saying.

The corridor was filling up, students were arriving to start their lessons. I spotted one of the pupils who I knew could speak Gujarati.

'Sanjay! Come here,' I said quickly, desperate to gather any information I could. 'I need you to translate for me. Ask Kalindee if she did this work.'

I watched as he asked her. Then he turned to me.

'She said she did. Can I go now miss?'

'Wait there,' I said, reaching a hand out to stop him being taken along with the crowd.

I looked down again at those tiny hands and slender fingers and then I saw for myself various coloured remnants of oil pastel still stuck underneath her nails.

'Oh my God,' I said, grabbing hold of Sanjay tight. 'She did do it.'

'Miss, can I go now?' he asked again, growing impatient, and completely disinterested in my obvious excitement.

'Tell her... tell her this is the most amazing drawing I've ever seen in my life.'

He stared at me for a second, as if I might have gone completely mad. Then he just looked back at her, said something very quickly – and, I imagined, understated – and ran off to join his friends.

'Come here,' I said, beckoning Kalindee into my art room with my hand. She followed, looking about her, confused. I started preparing a folder for her. In it I put a sketchbook, more pastels, a tablet of watercolours, some brushes, I ripped loads of pictures out of magazines, pushed everything inside the folder and pressed it into her hands.

'Draw anything,' I said, circling my arms up to show her. 'Anything. Understand?'

She smiled, and left as my first class started arriving.

'Are you OK, miss?' one girl asked as I stood there grinning.

'I'm great,' I replied.

I pinned the drawing that Kalindee had done up on the wall. For the whole of that morning I was distracted by it: the use of colour, the long, confident strokes of pastel, the blending, the definition, that child's haunted eyes. If Kalindee had done this in Year 8, I could not imagine what she would be producing for her GCSE year.

At break time I went straight to the EAL department.

'I must show you what Kalindee has drawn,' I said, holding it up on the wall in front of them.

Their mouths dropped open.

'This girl is so talented,' I said.

'You realise she's never been to school before,' the EAL lead told me.

I shook my head. 'That only makes her more special.'

As the weeks and months went on, Kalindee became a regular in my art room. English came to her very quickly, and she picked up a cute Gujarati-cockney accent as she started to speak. She was a brilliant student right across the board, but she became an ambassador for the art department – everyone in the school knew that she was exceptionally gifted. By then, GCSE grades had changed from letters to numbers, and Kalindee received a grade 9 for art – only 4 per cent of students in the whole country receive that grade. In fact, she got grade 8 or 9 in every single subject.

'You better be doing art for A level,' I told her. 'If you don't, I'm going to sabotage your entry form.'

She laughed. 'OK miss, OK.'

It is far from unusual for EAL students to go on to achieve high grades. In fact, data released by the Department for Education in 2018 showed that children who grow up speaking a language other than English actually score higher than their peers by the time they reach sixteen. It's incredible to think that these children, who arrive in this country with no grasp of the English language, go on to outperform native speakers. It's what I love about teaching EAL kids: they arrive at school seemingly on the back foot, and many have had little access to an educational institution, but they exceed even their own expectations. Once they feel supported in a school, there really is no stopping them.

It was 2005 when I first drove through those gates of Alperton Community School. It was not the place it is now – it was still that shabby Victorian building with its missing windowpanes, its peeling paint and dusty interior. The head teacher, Maggie Rafee, had inherited a school that was deemed as 'requiring improvement' – it was, at that time, the worst school in the borough, just as my father had warned. But she wanted to recruit an army of new teachers who were full of energy and passionate about its regeneration.

'We need to build an outstanding school,' she said in a tone that felt more like a pledge than a pipe dream.

Maggie gave us new recruits carte blanche to do with our classrooms whatever we desired. I spent two days

over the holidays simply making trips to the dump – out with the old and in with the new. But even when that was finished, my ambition spilled out into the corridors, first pinning students' artwork to the walls outside, and then extending that throughout the whole school building. There were two of us new art teachers in a department of four – me and my colleague Armando – and if the head of art minded the way we rearranged the classroom and stocked the cupboards, she never said. By then she was close to retirement and was happy for the department to receive an overhaul at the hands of two newly quali-fied teachers (NQTs) not beaten down by years working in such a dingy environment. But in the staff room we all heard the whispers, the resentment from some other members of staff, who saw us as little more than the new head's 'teachers' pets' – especially as it was always us who volunteered for extra work. Office politics can be tricky territory for new recruits to traverse – the seats in the staff room and the parking spaces can come with a pecking order, and all these unofficial rules need to be learned. Maggie was not backwards in coming forwards: she made an announcement that anyone who didn't like her new ideas could find another school to work in. I admired her strength and chutzpah. I could not have asked for a greater mentor in my first year of teaching.

I passed my NQT, and remembered my promise to my dad that I would just get one year of teaching under my belt and then move on to a better school. But there

was no way that I could leave Alperton when there was still so much to do. In the first two years I introduced an after-school art club. When that was instantly oversubscribed, I organised a lunchtime one too, and then one on Saturdays. I entered students who had previously gone unrecognised into art competitions, arranged school trips to museums and galleries, and even theme parks. And I didn't want to leave my form class, the Year 7 students who had started the school at the same time as me.

Maggie didn't want her new recruits to leave, either. She created jobs within departments to give staff an added incentive to stay. I got the role of associate teacher learning lead in our department, responsible for the students' art programme throughout the whole school.

At the beginning of my career I was sure that my interests were more curriculum based, only as I got to know my students better and found exciting ways to make their life in school easier, I realised that I was far more interested in the pastoral side. I'd been assigned a mentor who reminded me that often women can feel they need to meet 100 per cent of the criteria when applying for a job, whereas men will apply when they only meet 60 per cent, so when a job came up for head of year, I went for it. I was promoted to head of Year 9 – the same year group that my form class was in. But now it wasn't just their well-being and academic success I was responsible for, but that of 225 other children too.

Midway through the year was when I found out that I was pregnant. I took five months off to look after my new baby, Sophia. She slept well, ate well – she was the easiest baby – but something was missing from my life. I felt my brain was melting as I mashed banana, or sterilised another bottle, or jiggled Sophia in front of Igglc Piggle in In the Night Garden. I was missing a child that presented me with a challenge, or a class that needed colour theory explained. I craved the smell of my art cupboard, the feel of oil pastels clutched between forefinger and thumb, a classroom buzzing with noise that needed calming, even picking up unnamed work from the floor. I missed school. I missed the challenge of a school day, the unpredictability of it, the ups, the downs, the highs, the lows. I had one child, but I wanted twenty-four others. I couldn't wait to get back to work.

On the day that I returned to school a colleague told me in whispers that I could have a little cry in her office if I was missing my baby too much. But Sophia was fine, cared for by a Greek childminder who filled her belly with moussaka and flaounes almost as good as my grandmother's, and I was back among the students, the staff, the arguments to mediate, the playground scuffles to break up, and all the challenges of a regular school day – in many ways, I was home.

Fatima Kalb was another student for whom English was not her first language. In fact, when she arrived at our

school, she spoke barely a word of it. Fatima was a Syrian refugee, quiet and timid; she kept her head down most of the time in class and spoke in whispers to the girl she had been buddied up with. It was policy in my school to have all the support in place for Fatima, as an EAL student and refugee – counsellors, translators, psychotherapists – and I knew little about her background, only that she had suffered a traumatic journey to reach the UK. My job was to help give her back a childhood, simply by teaching her art as I would any other child in the class.

The first day she arrived, we were sketching a still life with pencils. I gave Fatima some paper and a selection of pencils, making sure she understood what she was meant to be doing. As I walked around the room, observing everyone's work, the room was filled with the gentle scratch of lead on paper. I paused to show students how to improve their shading, or how to make their outline clearer. But from the other side of the class came another – much louder – sound. I made my way across the room and realised it was coming from Fatima's desk. I went and stood next to her, she looked up and I smiled as she continued with her work. The paper that I had given her was covered with large and angry pencil marks that had almost torn through to the other side of the sheet. I watched as she worked, her face set in concentration, her forehead wrinkling. I saw how her jaw clenched, her fist tight around the pencil. The drawing had little resemblance to the still life, but I could see that Fatima

had something inside her that needed to be expressed. Perhaps this lesson was the only outlet for some of her emotions. After the class I collected up all the work. I turned her piece over – the scratches felt more like Braille, if only I could read what she wanted to say.

As the weeks went on, I gave her different media to work with, always letting her draw whatever she needed to. I wasn't sure then of the story behind Fatima's drawings, but I knew that this class was more of a therapy for her. I gave her charcoal, observed the huge, thick lines she scratched across the page. The following week, while the other students were painting, I gave her wire and asked her what she could make of it. She seemed happy in that silent world, building and perfecting huge, complicated sculptures, communicating to herself – if not yet to us – exactly what she had been through.

Over the weeks and months, her trust and faith in the school developed. Her EAL support team told me how much she was gaining from the lessons. They told me that she was a 'threshold learner', which meant that she was completely new to English. I realised how much my art class must be an escape for her: the chance to express herself without the need for words.

Gradually, through art and as she grasped English better, Fatima started opening up to me about her experiences before she reached this country. She had arrived here as an unaccompanied minor. Her father had organised safe

passage for his children to this country, but he and his wife were unable to travel with them.

'We come alone with my brother and sister,' she told me. 'We not knowing we are coming. Just my father, he wake us in the night-time and say, "You must go." '

With only the clothes they had on their backs and no time to gather anything else, Fatima and her siblings had been herded from the house in the black of night and into a truck with strangers. All she had been given was the address of an aunt in the UK. Once they arrived, the children had been taken in by social services, and that's where they'd been living when Fatima arrived at this school. It was clear she had lived with so much uncertainty. In Syria she had witnessed war: bombs dropping and the sound of gunfire had been her norm. And suddenly, everything she knew – however frightening – had been torn from her and she'd been sent to a foreign country with no idea of if or when she would see her parents again. Fatima was a brilliant, intelligent girl, and the more language she picked up, the more this showed in her studies throughout the school. But I knew that art had been a way of accessing this new normal for her; her creations had given her the confidence to speak out as soon as she found the words.

For Remembrance Day that year it was my job to put together an assembly for Years 7, 8 and 9. I wanted to do something hard-hitting, something that would help the students to understand and connect with the events of

the past. I spoke to the ICT team, who were helping me with my slides and music – I'd given them sound files of air-raid sirens and machine guns – and I told them when the time came, I wanted them to play them really loud. On the day of the assembly, I read a selection of poetry from both world wars, then I asked the 600 children to close their eyes and try to imagine what people living in those conditions had felt. The sounds started playing through the speakers, loud enough to reverberate around the whole school – just as I had asked. But in that crowded room packed with students, I looked up and locked eyes with Fatima sitting cross-legged on the floor. Her eyes were wild, her pupils large, black pools of fear, and in her lap, her hands trembled. I realised that these sounds I had put on to help hundreds of other children conjure up feelings in their imagination were actually making her remember life before she reached the safety of these shores. I felt terrible. There was an obligation to continue with the assembly, but afterwards I went straight up to her.

'Fatima, I'm so, so sorry.'

'It's OK, miss. These sounds are very familiar for me.'

'It was thoughtless of me,' I said.

As a teacher it is impossible to get it right for everyone. I am often reminded of my privileges, that what I know and have experienced is not the same as what all our students have experienced. Fatima's story was a sobering reminder of the difficult lives some of our children have

to contend with. It's incredible then, with all the adversities that students like Fatima have faced, that they can go on to achieve so much. I could not imagine how difficult that journey had been for her to make, but I was grateful that she had. And when her parents arrived in the country, she could finally live safely for the first time in her life.

Six

Binal Kapoor was an A*-grade student across every one of her subjects. Her family were from India and they valued education highly, almost beyond anything else. Socially, though, Binal struggled. I can't remember her being surrounded by friends, but she was well-behaved, polite, quiet and shy, kind and committed to her studies. Her parents had no reason to worry about her.

Yet, for some reason, she lingered long after every other child had left my classroom.

'Miss, I can do that for you,' she would say, taking a stack of paint palettes from my arms as I headed to the sink to wash them.

'You really don't have to, Binal,' I told her.

But she insisted. By the time she finished, it would be almost four o'clock, but instead of picking up her bag and leaving, she would get to work straightening my desk, tidying up around the art room, cleaning the paint-splattered sinks. She was one of the few pupils who knew where I hid the art-cupboard keys – that's how much

I trusted her – and she only left when I switched off all the lights ready to head for home myself.

Binal spent break times and lunchtimes at the back of my classroom too, catching up on extra work, drawing in fine graphite lines – every single one of her illustrations showed so much potential.

'You're a very talented girl,' I told her.

'Thank you, miss,' she said.

I knew she would go to university. She had the pick of any subject, yet I hoped that she would choose to study art at A level.

Binal always arrived early for school, and often it was my classroom where she would set up her studies, and as she drew, we would chat, and over the five years that I taught her I slowly came to learn details of her life. From her clothes, I assumed that she came from a very poor household. It was clear that she wore hand-me-downs that had seen many lives, perhaps in this same classroom.

'Do you have any brothers and sisters?' I asked her one day as we worked, me at one end of the classroom, she at the other.

She nodded. 'I have two sisters and one brother,' she said.

'And do you draw a lot at home?' I asked.

'It's not easy for me to find somewhere to draw,' she said. 'Sometimes I have to sit on the stairs at night-time.'

I nodded. For kids, the way they live is their normal. It's important not to react or to make them feel conscious

of their home life, but I was curious about her set-up. It sounded as if her life was difficult, though I would have to wait for her to tell me more.

Another time I set the students a task to draw their bedroom.

Unusually for Binal, she didn't pick up her pencil once I told the students to start. I went over to speak to her.

'Miss, it's very hard for me to draw my bedroom. We all sleep in the same room,' she said.

'You share with your brothers and sisters?' I asked.

'No,' she said, 'my parents too – we only have one room inside the house.'

I saw a couple of other kids lift their heads, and positioned myself so I was in their eyeline.

'Well, that's OK. I just want to see that you can draw three-dimensionally,' I said. 'Why don't you draw a picture instead of your fantasy bedroom?'

Binal smiled, relieved. 'OK, yes miss,' she said.

There are many students in our school who live in the kind of conditions that Binal had described to me. There are families that rent three-bedroom houses along with three, four, even five other families. The living room and dining room are turned into bedrooms that each family squeezes into. The only communal areas in the house are the kitchen, the bathroom and the hallway – all shared. Sometimes these other families are aunts and uncles, other times they are strangers. I knew of kids who squeezed into a box room alongside their parents. For

these children, a quiet place to study was near impossible. It suddenly made sense to me why Binal arrived at school early and left late.

In our borough of Brent, it is estimated that 33 per cent of households live in poverty. It is one of the London boroughs with the highest private rental markets compared to the number of low earners, and evictions are not uncommon. In fact, a 2019 Trust for London survey revealed it is the borough with the second highest number of people evicted from their homes. It is no wonder, then, that people who live in conditions like this long for their children to do well at school, so that they will make a better life for themselves. In my experience, many families will value education higher than anything else, and parents will often sacrifice food where necessary for their children to receive private tuition. Binal was expected to work hard at school – her family believed it represented her only chance for escape. I noticed, too, that Binal worked more quickly than other students and now it made sense why. She was studying twelve or more GCSEs, and with nowhere at home to work, she had learned to be efficient, to get as much done at school as she could.

In her final year of GCSEs, Binal and I were sharing the classroom after school while she finished off a piece of textile.

'Are you going to do A-level art after this?' I asked her.

She looked up, for a moment unsure how to respond, then her gaze fell to her needlework.

'Miss,' she said, 'my parents don't even know that I have been doing GCSEs in art and textiles. They don't know I picked these subjects; if they did, I would be in so much trouble.'

I stared at her for a moment, trying not to show any reaction on my face.

'But all the work you've been doing...' I started; I didn't know how she had managed it – her work was outstanding.

'I have been doing it secretly, miss. Sitting in the hallway at night when they have gone to bed. I use the torch on my phone so I can see.' She picked it up, as if to demonstrate.

I had heard stories like these before, of kids who worked in an empty bathtub because they had nowhere else to sit. But I suddenly felt incredibly sad that Binal – a girl with such talent – had been fulfilling her passion in secret from her parents. For a child like Binal, these secrets are commonplace; every day they tread a fine line between fulfilling their own ambitions and the dreams decided for them by their parents. Ultimately, she would fulfil their wishes, not her own, because as soon as she started earning, she would be expected to contribute to the same household that raised her. There is a high expectation for these children to do well: it is embedded in them to succeed, to be doctors, lawyers, pharmacists, to earn good money, to own their own house, their own car, to do better than their parents before them. For

many parents there is little value in children taking arts subjects. It is considered a luxury to paint or draw or play an instrument. All cultures are rich in terms of arts – you only have to look at the stunning saris made in textile factories in India – but for some parents, the reality of the factories that make such beautiful threads is that they are sweatshops, that people are paid a pittance to work in often terrible conditions. If Binal was to say that she wanted to go into fashion design, this might be what her family would picture. And perhaps I understand this migrant mentality, because it was exactly the way that my own parents thought when I was a child.

My love of art extends as far back as my own memory, to the days when my mother would pick me up from nursery and ask: 'Why can't you ever come home with clean clothes?' Mine were speckled with poster paints and wax crayons, glitter and glue. At home there was always a plentiful supply of paper, and each weekend when we went shopping on Camden High Street, we'd stop at Woolworths, and while my mum was busy collecting her own shopping, I'd be in the craft section, picking pipe cleaners and packets of shiny, sticky paper from the shelves.

Mum would bring the *Radio Times* home from work and I'd spend hours copying the pictures and photographs in there: adverts for garden shrubs, bulbs and pagodas became portraits of flowers; looking at celebrities

advertising TV listings was how I taught myself to draw people. By the time I was ten, Mum subscribed to *Hello!* magazine, and each week I'd flick straight to the back to copy new fashion styles, perfecting my pencil sketches of model poses and the particular way the fabric hung from their frames. But there was more treasure to be gleaned from those magazines – celebrity holiday shoots were an explosion of colours. I'd take Mum's kitchen scissors and pick from the skeleton of the magazine a patch of azure-blue sea or a speck of indigo sky. I saved everything, filing a collage of ideas into plastic folders Mum brought home from work. On birthdays, it wasn't only my presents I looked forward to, but preserving the wrapping paper they arrived in, cutting out squares to collage with later. I had watched my grandmother for years making do and mending: the Stork margarine tubs that were washed out and used for food storage, jars of honey soaked in soapy water and dried to store spice mixes. From her I had learned thriftiness, and so I never let anything that might be useful to an art project get thrown away. Slowly I commandeered the kitchen at home, a drawer of art supplies giving way over the years to a small cupboard, and then a large mahogany cabinet that I gleaned from the skip at school.

When I was eleven, my mother brought home a book called *Glorious Inspiration* by Kaffe Fassett, an A3 book packed with colours and patterns from the natural world and examples of how they were used in modern-day design.

There were portraits of birds and the intricate patterns their feathers made; shells found on beaches and all the markings the sea carved into them as they twisted and turned with the tide; there were other animals and reptiles, scales and fur, each picture sitting beside an artist's interpretation of it. I took this book everywhere with me; it was my reference for any piece of homework I did. My parents understood and nurtured my love of art – they indulged what they believed was a worthwhile hobby, but nothing more. When it came time to pick the options for my GCSEs there was never any suggestion that I would take art as a subject. I came home clutching the yellow option paper that my parents needed to help me fill in. Alongside compulsory subjects like English, maths and science there were the subjects that I was to choose from, putting a tick in one of three boxes. Art sat alongside history, and my pen hovered above it. My father took the paper away from me and studied it hard.

'Your sister took history,' he said. 'She will be able to help you if you get stuck.'

'But I want to do art,' I said.

'Art isn't a GCSE,' my mother said, shaking her head. 'It's your hobby. There are no jobs in art.'

I didn't know then what I know now. But what I knew instinctively were my parents' reference points. We had no friends who were successful, rich artists. There was no one at church who was an architect or painter. I had uncles who ran textile factories, but they

were no high-end fashion houses, only the rag trade. My parents saw those uncles working eighteen-hour days to get clothes into Topshop; they saw that they never spent time with their families. Was that respectable? My grandfather had been a potter: he had worked with mud and clay all day back in the village. Was that respectable? Or my grandmother's weaving, her factory of silkworms that she had abandoned back in Cyprus. Was that respectable? I didn't need to ask. Hadn't my family always hoped for more from our generation than what they had done to make ends meet? The saying that you cannot be what you cannot see was never more true than in that moment.

'No, you will do history and geography,' my father said, and with that he marked each box with a giant tick. And so it was decided.

'You can do art in your own time,' my mother assured me.

But my heart was already broken.

The following day at school I handed in the form to my tutor and on the way home my cousin, Andrianna, asked me if I was taking art.

'Mum and Dad won't let me,' I told her solemnly.

'Oh my God, you're joking. You're brilliant at art. It's your thing.'

I knew it was no use. But Andrianna's outrage had unsettled something in me – she had expressed the injustice that I was unable to voice.

Six months later Year 10 arrived. I sat in my history class staring at the wall – I had no interest in the subject. I didn't like my history teacher and knew that I would clash with her. I didn't have the natural affinity with history that my peers did; I had no interest in or memory for dates. Two weeks later my cousin called me at home.

'I took the tube home with Miss Dromgoole,' she said. 'She can't believe you're not doing art. She said, compared to everyone else, you're on a different par.'

I'd never heard that phrase before.

'What does that mean?' I asked.

I heard Andrianna shout over her shoulder to my aunt, who took the receiver.

'It means you're better than everyone else, Andria,' my aunt explained, 'that you're in a different league.'

Why, then, had my art teachers not fought harder for me to stay in their class? If only they had tried to persuade my parents.

By the time I put the phone down, a plan was forming in my mind. The following day I went to speak to my head of year and, with tears rolling down my cheeks, I explained just how unhappy I was with the choices that had been made for me. I went to see Miss Dromgoole, who told me that as long as I could get my parents to agree, she would let me transfer out of history and into her class. Once I had everything in place, I spoke to my parents. They were eating dinner at the kitchen table when I appeared at the bottom of the stairs. My heart

was racing wildly inside my chest before I even uttered a word. I had spent the last hour up in my bedroom, psyching myself up for what I might say. I had practised in front of the mirror, but in the moment, emotion got the better of me, and my longing for art came tumbling out in one long sentence without any pause.

'… so I just wanted to let you know that from Monday I'll be switching to art,' I said, breathless by the end of my lengthy monologue.

My parents, who had sat listening to me with their cutlery suspended mid-air, food going cold on their forks, didn't say a word. Instead they returned to their dinner, which I took as acceptance of the decision that I had made.

I spent that weekend catching up on the two weeks' work I had missed in class, and by Monday I was back among the paints and pastels I had missed so much.

I'd had no idea that Binal had kept her GCSE secret from her parents for two years. But she knew that by the time it came to A levels, there would be no hiding. She had accepted that she would take the normal route of many kids from her community: she would study chemistry, biology, maths and physics. She succeeded, as I knew she would, getting As in every subject and securing a place at a top London university. I assumed I would never see Binal again, but the following February, in her first year at university, an email from her popped into my inbox.

Miss, can I come and see you? she wrote.

A week later she sat down in my art room. As she glanced around familiar surroundings her shoulders sank away from her ears and then she started to cry.

'Binal, what's wrong?' I said, reaching for her hand.

'I can't tell you how horrible the last couple of years have been for me,' she said. 'I did what my parents wanted, I studied for the medical degree they chose for me, but when I got to university, it was a different world.' She paused. 'I met a boy, an artist – he was studying one of the courses I would have chosen. He reminded me how much I loved all of this.' She indicated towards the classroom. 'My parents found out about our relationship. They were so angry. I left home to be with him, and they disowned me. Now I have lost everything. But I want to be with him, and I want to study art – will you help me put together a portfolio?'

She told me that she had dropped out of the medical degree and was now working in a shop on Wembley High Street.

'I spend every evening drawing and painting,' she said. 'I wondered if you would have a look at my portfolio, if you could tell me if it's good enough to apply to art college.'

I wanted to tell her that even her GCSE work would have been good enough, but I did as she asked, flicking through her sketchbook, helping her to pick which pieces to discard and which to work on. I suggested a few artists that she could research, people she could link

her own work to so that she could demonstrate critical understanding. I told her we could practise mock interviews too.

'It will be OK,' I told her, as she got ready to leave.

She sniffed, gathering together her artwork. I could see how much she had been through, how painful it had been to separate from her parents. I wondered how different it might have been if they had allowed her to study art, if she had fought harder – if I had fought harder for her. I made a promise to myself then that I would fight for every child in the future who wanted to study art. That I would make it easier for children to show their parents the value of art.

Binal did eventually go to university to study art. Since then, I have kept in my drawer a sheet of paper that I have photocopied hundreds of times. It is a list of every job that a GCSE or A level in art can lead to. Alongside each job is the starting salary in that particular profession. There are architects on there, creative directors, photographers, graphic designers, ceramicists, illustrators. For many families – particularly those from minority ethnic or working-class backgrounds – the arts can feel like an industry that is still impenetrable to them. It appears dominated by the white middle classes, the assumption being that those young people are supported enough not to have to worry about making a decent living. I know that's how my own parents felt.

Binal was far from the only student of mine who was in that position. For every intake of children in Year 7, there will be a handful of talented artists among them whose parents will forbid them from studying a subject that would easily see them win an A-grade certificate. If I get the sense that will be the case, I tell them straight away at our first Year 7 parents' evening. 'I'm just going to say your daughter is one of our most talented artists, and without any question she should be doing GCSE art,' I tell them.

It's pride, not conflict that you see spread across their faces. What parent does not take pleasure in hearing how talented their child is? And then they'll say: 'She gets that from her aunt – she was brilliant at sewing,' or, 'Her grandfather liked painting as a hobby.' It's always lovely to see how they make that emotional connection to their family and their own genes. Often you'll even hear parents say: 'When I was her age, all I did was draw. It was the worst decision I ever made not to study art.' For that reason, most parents still long to live vicariously through their children. They want for them the opportunities that they were denied.

Many parents wouldn't know that an architect can earn upward of £80,000 a year. Why would they, if they don't know any? When it comes to kids choosing their GCSE options, I make it clear to my students that if they have any concerns about taking art, they should speak to me. In each year group there will be three or four kids who

are afraid to tell their parents about their longing to be an artist. It's these kids that I arm with that sheet of paper listing every job and salary. It's them who I bombard with dialogue to go home and tell their parents. I offer to call them myself. Some I win, some I lose.

Binal had the conviction to follow her dreams. But there are many children who aren't brave enough to defy their parents.

Geeta made the mistake of not opting in for the textiles GCSE. It was the first year that we had run it, and the class was so big that tables and chairs spilled out into the corridor. I would see Geeta staring in through the window, desperate to join our class, but we just didn't have the space to take another student. A few weeks later I went on maternity leave, and somehow, while I was away, my colleague snuck her into my class.

'I know you won't be very pleased with me,' he said.

But just one glance at Geeta's work was enough to tell me he'd done the right thing. She was supremely talented, another Gujarati girl who was an A-grade student across the board. It was clear that she had a great future ahead of her. Like Binal, she had the pick of subjects to study at A level, but unlike Binal, I knew she wasn't afraid to pick art. Naturally she achieved a grade A* in textiles at GCSE.

Only when the new school year started, Geeta was absent from Year 12. I tracked her brother down in Year 9 and asked him what had happened to his sister.

'She got married, miss,' Salim said, breaking into a huge smile. It had been an arranged marriage, a match her parents had made on her behalf. Salim's eyes were wide as he described the lavish ceremony, the colour, the decorations, the food, how beautiful his sister looked as her hand was received by the new husband she had met just a few times before.

'She is very happy, miss,' he said, proudly.

'How wonderful,' I told Salim as he stood smiling. Of course, it pained me that a sixteen-year-old girl with so much talent had cut short her education to become someone's wife, but Geeta appeared to have willingly fulfilled her parents' plans for her.

'Send her my love,' I told her brother. 'We miss seeing her around.'

In school there is never time to dwell too much on one particular student. The terms keep coming, and before you know it you've completed another year. It was two years later that I asked Salim again about his sister. This time there was no smile.

'The marriage didn't work, miss,' he said. 'Geeta is getting a divorce.'

He said this last bit quietly.

I lead him to one side. 'What happened?' I asked.

But I could see he felt uncomfortable explaining. I knew not to push him, but the following day I received an email from Geeta herself. In it she painted a picture that was painful to read. As is tradition, after she had

married, she had gone to live with her new husband's family. But in their home she had been treated badly. The money she earned from working in a shop was taken from her, and the hours under their roof were always spent cooking and cleaning for the family. Her husband was not only unsupportive, but also violent. In her email she had referred to herself as a slave. And worse, she had effectively been paying them for the privilege of being mistreated. Her parents had taken her back in, they had not shamed her, and they were fighting for her divorce. But with this new-found freedom the world had once again opened up for Geeta. She signed her email off by saying that she wanted to get onto an art foundation course so she could study fashion design at university.

'Can you help me, miss?' she pleaded.

Just as I had with Binal, I went through Geeta's portfolio with her – it didn't matter to me that they weren't current students of the school – how could I not do everything I could to help? Geeta was granted an interview at a college close by, so she could continue living with her parents while she studied. Eventually she went on to do a fine art degree at university. Today she is an illustrator for children's books. She came to see me not long ago and showed me all the stories she had illustrated – although none were as powerful as her own.

Is it any surprise that girls like Geeta and Binal did not realise earlier the benefit and importance of studying the arts? How are they meant to persuade their parents that

creative subjects can lead to distinguished and successful careers if the message we get from government is that these subjects are not worth investing in? If more importance was placed on those subjects in schools, then that would filter down to both the parents and the students. Not valuing the arts in society in general is something that needs to be addressed, otherwise other talented young artists will slip through the net. Geeta and Binal will be shining examples in their communities, a reminder that you cannot be what you cannot see. They, and students like them, will inspire others as a result of following their own hearts.

Seven

Should the government want to understand and improve the lives of today's schoolchildren, ministers need to speak to teachers. We are the ones who go above and beyond the duties we were employed for. Our job is not just about classroom learning: we pick up on eating disorders, or drug addictions, on issues of neglect and abuse. We are the ones alerting social services to child-protection issues, severe poverty or the fallout of police intervention. We are the ones writing letters to GPs with concerns about a child's asthma and the inability of councils to provide homes that are not riddled with damp. Instead of asking what changes need to be made in the curriculum, the government should ask us what kids' lives look like in the twenty-first century, about their mental-health issues, or self-harming, about going hungry, or the abuse they witness at home. This is the information that is not captured by the facts and figures they demand from schools, and yet it is the nuts and bolts of what we deal with every single day. And we have

to fix these issues before the teaching and learning can happen.

Gemma was a kid with chutzpah – but what her story stresses is the importance of communication between teacher and pupil. As I write this, we have a new schools minister, Gavin Williamson, and one of his big pushes is silent corridors. This minister believes that discipline is the key to good education, though in my experience it is quite the opposite. Anything that opens up a dialogue between teacher and pupil – or even between students – is, to me, beneficial. There is only so much a child will reveal to their teacher and so, to get a better idea of what's going on in their lives, a lot can be gleaned from what is overheard in the corridor as kids are moving between classrooms.

There is a school just five minutes from ours that has already implemented this new government push for silence. The children walk around noiseless corridors, but does this method really make pupils behave better, or is it just applying a Band-Aid and ignoring the real issue? The truth is, problems with behaviour in schools are not down to the students – they are down to the lack of resources. There is so much more that needs fixing: the fact that teachers are working in buildings that should be condemned, that we can't afford to fix the roof, that we don't have adequate funding for the provision of equipment, and, crucially, that teachers aren't given the training to deal with students with learning disabilities or

behavioural issues. The answer is not to close down the conversation between staff and pupils. In my experience, what is needed is understanding and mutual respect. It's investing in pastoral care in schools instead of leaving our very limited resources to be stretched over so many hundreds of pupils. It's during pastoral care that you plant the seed for a child to think about their behaviour, or how they interact with the world. Not by shutting them down.

Many of the schemes that our school has introduced have opened lines of communication. For a lot of our students, breakfast is not a given. It wasn't long into my career as a teacher that I became used to the sight of a mostly empty Tupperware box opened at lunchtime. I'd see kids crowding around the ones lucky enough to get dinner money, pinching a chip here and there, asking for more. Hunger fed their fatigue, which in turn would give their anger appetite. Before lunch those kids were impossible to teach – during PE it wasn't uncommon for one or two to pass out. When we started a free breakfast club, it wasn't only behaviour that improved, but attendance – children were getting to school on time simply because they were hungry. Some people might think that we're taking on the responsibility parents should have, but in my view, school is a community, and it can make an enormous difference. But what I hadn't expected when we first set up the breakfast club was how our kids would talk to us – how they would open up and tell us what their home life was like, why they needed the sanctuary – and

the food – that we provided. And we learned all this from spending just £1 a day per pupil from the school budget. And in turn, because they weren't hungry, not only did their behaviour improve, but also their ability to learn. By 7.45 a.m., we'd have a queue of a hundred kids waiting to get into school.

It was at breakfast club that I got to know Gemma Baker properly.

Gemma was a wild girl. She was impossible to control. In a way, that was exactly what I admired about her: Gemma was an individual, another kid who had walked through our school gates having already triumphed against the odds. She was eleven when I met her, a beautiful mixed-race girl with gorgeous afro hair. She was already infamous in the school – so many teachers had called home already complaining about her behaviour. You would hear her coming before you spotted her. She had a mouth on her that she wasn't afraid to use, and it wasn't unusual to hear her effing and blinding at teachers, slamming doors as she was thrown out of the classroom. She would argue with anyone over anything. Given her background, though, it wasn't difficult to understand. Gemma was a 'looked-after' child, which meant she was in foster care. She would, over the years, reveal bits of her life to me, peeling back another layer with every conversation we had. She told me both her parents were drug addicts who had given her up as a baby. She had never

been adopted; instead she had moved from family to family. She had nothing and no one.

'My foster mum only looks after me for the money,' she said.

It might not have been true, but who knows? It was how she felt.

Gemma had learned to hide her emotions; she had hardened herself to life – how else was she going to get by? She was feared by other students, and with good reason, and she acted like she was afraid of nothing. But I loved how strong she was. One of the things that endeared her to me was how she always stood up for the underdog. Once, in my class, one of the Indian girls with a thick Gujarati accent asked a boy to pass her a ruler. The boys started mocking her accent, but Gemma was on their case immediately: 'What are you cussing her for?' she snapped. 'Look at the way you dress.'

The boy backed down immediately.

For all Gemma's mouth, she still had a decent moral compass. She helped kids who were vulnerable, who were defenceless and isolated.

Another reason I liked her was – again, unlike other kids – she always admitted when she was wrong.

'Why did you cuss your teacher, Gemma?'

'But miss, he was annoying me.'

'Why was he annoying you?'

'Because he told me off.'

'Why did he tell you off?'

'He told me off because… because…'

I waited for the reality to dawn.

'Oh miss… it *was* my fault.'

Her honesty was part of her vulnerability. She had her own special needs too: she was severely dyslexic and barely able to read or write, which is probably why she found it difficult to concentrate in class, why she was so easily distracted. But the main reason we got on so well is because she was a brilliant artist. She had natural talent. She loved fashion design and could draw the most intricate clothes on models. In my class she was not the volcano she was in others; instead, she was quiet and perfectly behaved.

Perhaps there was also a part of me that enjoyed being one of just a few teachers who could calm this storm of a girl. I admit that I was flattered when my colleagues admired my ability to get through to her when no one else could. Perhaps there was a little part of Gemma Baker that reminded me of myself as a girl.

I grew up surrounded by strong female role models. One of the most important people in the Greek culture is the mother – the Virgin Mary – so I have always felt there was a huge appreciation of the woman and all her strength. My grandmother was the family matriarch. To this day, I've never known anyone stronger. As she showed us how to prepare *trahana* soup she would tell us stories of her

sister, Flora, married fifty years to a dog of a man who treated her terribly. He never called her by her name – instead he addressed her as 'woman'.

'Woman, get my coffee… Woman, pass my book.'

My grandmother would tut slowly, rolling her eyes to the sky, and wringing her hands inside her apron. My own grandfather wasn't a whole lot better. We never saw much of him growing up; instead he travelled the world, leaving my grandmother with a family to raise, cook and clean for. Back in Cyprus she had been well known for intricate lacework that she wove from strands of silk she farmed from her own silkworms. When the war broke out, she was commandeered to make parachutes for the army. I've often marvelled how she turned her art form into something strong enough to hold a human life.

She taught us girls *nikokiria* – the art of running a home. The girls would prepare the food, do the dishes and all the housework while the boys sat in front of the small portable black-and-white television.

'What about them?' I would ask my grandmother.

'They don't have the brains to do this work that we do,' my grandmother would say, wafting away complaints at any injustice.

I was satisfied by her answer, just as she knew I would be. I grew up convinced that females were the superior sex, that if my grandmother could turn her hand from weaving lace to soldiers' parachutes – all while raising a family – we really could do anything.

My grandmother had already instilled in her own daughter this *nikokiria*. My mother couldn't have been stronger if she was cast from iron. My father earned a pittance from the church, and so she was both home-maker and breadwinner. As a girl she had turned my grandmother's black hair grey. The wild child of the family, she left for school each day and rolled her skirts up into her waistband, covering her face in make-up once she got round the corner. But when my father arrived from a tiny village in the south of Greece, assigned to the church where my grandparents took communion, he fell in love with my mother as he passed her the bread and the chalice filled with red wine. No one – least of all my grandparents – had expected their daughter to settle down, especially not with the community's deacon. But this village boy had probably never met a girl quite like my mum, a girl so feisty that she would argue with anyone and everyone. She refused to stay home and keep house, and it was her wage as a programme administrator at the BBC that kept us afloat.

I learned from her to challenge authority and to hold my own against my cousins. I gave more than one of them a bloody nose when I was growing up. I was fearless, just as she had been. I refused to grow into a nice Greek girl. My family had known when I was a child that I would be hard to handle. My father told me over and over the story of an old friend of the family who had spotted that trouble in me as a child. As I fought with my sister,

Maria, over a toy, he had shaken his head at my father and warned him: 'That one – Maria – she is the calm. She will not give you any problems. But Andria,' he raised his hands to the heavens, 'she is the storm of your seas, she will give you so many headaches – you will always have your work cut out with her.'

At school I was confident and popular, but years of wrestling with my cousins meant I was tough and rough too. But my teachers liked me because I looked out for the new kid in class, because it was me who would take anyone different under my wing.

Ibrahim Ilgin's father owned a chip shop in Camden, and the fat must have drifted between the floorboards to their flat above, because Ibrahim smelt like grease every day. He wore brown trousers that didn't quite do up over his tummy, and T-shirts that refused to meet his waistband, so his belly button always peered through the gap. He was a lonely boy with few friends, and when it came to picking teams for rounders on the school field, he would sit down as soon as the captains started to choose – knowing he would always end up last. One day during PE my teacher made me captain, and I scanned the crowd. Among them, Ibrahim sat down quietly, picking at the grass that grew around his plimsolls. When I said his name, the class replied: 'What?' and even my teacher did a double take. But Ibrahim was up from the grass so quickly his trousers were momentarily left behind, and all the other students laughed as he showed an inch of

butt crack. Not that he cared – it was the only time he'd ever been picked first.

'That was a very nice thing you did, Andria,' Miss Enoch told me after the game.

As unruly and stormy as I was, I always listened to my father, and he had told me time and again that kindness was the very best quality in a person.

I had high hopes for Gemma. I knew she had the ability to succeed. She may not have been able to read or write, but if she applied herself, she could get a grade B in art. If she concentrated on her studies and stayed out of trouble, she could even have made it to art college. I felt privileged that, out of the whole school, it was in my classroom where her skills were honed, and flattered that she listened to me in a way she didn't to others. I was convinced that I would be the one to turn this kid around.

'This is brilliant,' I told her, when she shared her sketchbooks from home with me – almost always fashion models wearing beautiful designs. 'Can I show you how to improve it?'

She handed me the pencil and I demonstrated how to draw the shape of the skirt with more accuracy.

'Think about how it hangs on the body,' I told her, tracing a curved line with a pencil. 'See how it looks now?'

'Oh yeah, miss, that's loads better.'

It was times like that when Gemma would talk to me, when she would let slip details about her home life. How

her foster mum had four children of her own to look after, how they were all crammed into a tiny council flat.

'I don't like it at home, so I just hang around on the streets,' Gemma confided.

I worried about her. In school hours I filled her art folder with materials: sketchbooks, oil pastels, pencils and watercolours. In my head this was encouragement, perhaps, to find a quiet corner of the house to draw, hoping that this might keep her away from the streets, though maybe that was a rather naive thought.

I knew Gemma trusted me, so often I stepped in when she was arguing with another teacher – afraid that if I didn't, her temper would flare and she would do something that she regretted. And I knew, even though she couldn't control her anger in the moment, that she would regret her actions afterwards. There have been many students that I have encountered during my years of teaching who suffer from behavioural issues. We forget that learning to control our emotions is a process and is something that needs to be explained and demonstrated to children – it is not innate. I have strategies that I share with kids, things that I have done myself when I have felt I was not going to be able to keep a lid on my temper. I share these moments with kids because it's how I connect with them on a very human level – they need to know that adults make mistakes too, that we struggle to contain ourselves, that this is something that we, too, have learned to do.

'If someone is in your face and screaming at you, start thinking of the alphabet and naming animals. A is for ant, B is for baboon. Go through the whole alphabet until they've got you out of their system,' I told Gemma. 'It doesn't matter if it's one of your friends or your teacher, just switch off and start going through the alphabet and see how many animals you can get through.'

She nodded, closing her eyes and picturing how it might work.

I tell all the kids the same thing because I know it works. I've seen them do it – that slightly vacant expression. It gives students breathing space that they might otherwise have filled with an action that could see them excluded. It stops them doing something stupid.

But some kids, no matter how much you intervene, are destined to take their own path.

Gemma was in Year 10 the afternoon the police arrived at our school. It was almost the end of the school day, and a rare occasion when both the head teacher and the deputy head were away. By then I had been teaching for eight years, and had recently been promoted to one of the assistant head teachers. As one of the senior leaders in the school that day, it was the phone in my office that rang first.

I went down to meet two uniformed officers who waited in reception.

'Can I help you?' I said.

'We're here to speak to one of your students,' the younger officer said, pausing to flick through his note-book. 'Gemma Baker?'

'What's this about?' I asked.

'That's not for you to know,' the officer replied.

I felt my fist clench around the pen I was holding.

'Well, she is a pupil at this school and under our care while she is here, so I think I do need to know,' I said.

He told me that there had been an incident at the weekend and a girl had been physically assaulted. She had reported the attack, telling police that Gemma attended our school. They had found CCTV footage, and they were here to take her in for questioning.

'You want to arrest her?' I asked, shocked.

The officer nodded.

'But she's just a kid.'

They were unmoved.

I asked the receptionist to check Gemma's timetable and find out which class she was in. It was geography. I knew it was going to be tough to get her out of class without the risk of her bolting, or feeling humiliated in front of her peers.

'I think I need to talk to you about Gemma's back-ground,' I said. I called my colleague Miriam to accom-pany us to the conference room. There I filled the police in on what I knew of Gemma, what a difficult life she'd had. I needed to make an appeal on Gemma's behalf, to

remind them that she was just a fifteen-year-old girl. Perhaps, I foolishly thought, if I did, she would get away with nothing more than a warning. But the officer was insistent that they wanted to talk to her themselves at the station.

'But she's a minor,' I pleaded. 'Could you not talk to her here on the school premises with one of us present?'

The officer appeared to be losing patience; he was talking about obstructing the police. I knew I was running out of time.

'We can call her foster mum,' I said. 'We can get her to come here too. Just say that you'll wait until she gets here before taking her to the station.'

The officer appeared to agree to this plan. I left them to go and take Gemma from her class. When I got to the humanities department, I paused outside the door. Inside Gemma was sitting at her desk – distracted as always, but oblivious to what was about to occur. I opened the door, explaining to her teacher that I needed a word with Gemma outside. Every child in the class turned to look at her as she crossed the room. She looked confused as the door closed behind us.

'I ain't done nothing, miss,' she said.

I took her down to my office and shut the door, asking her to sit down.

'What's going on, miss?'

'Next door I have two police officers who want to have a word with—'

I didn't get a chance to finish my sentence: she was already out of my door, screaming, running. I was up out of my seat after her, but not quickly enough. The police officers must have heard the commotion from the conference room, and they came outside too, speaking into their walkie-talkies. By now other teachers were coming out of their classrooms to see what all the noise was about. Several students followed them. This was exactly what I had hoped to avoid.

'Gemma!' I called, running after her.

She was still in the corridor, screaming and crying, too terrified to think of a route out. She reminded me of a trapped animal, her eyes wide, all anger and fright. I approached her carefully, and she looked at me with complete terror on her face; she was hyperventilating as if she was having a panic attack.

'Gemma,' I said, quieter this time, putting my hands out towards her so she knew there was no threat from me. 'Your foster mum is on her way. Don't worry, we're going to be with you here when the questioning happens. You're safe here.'

'Don't let them take me, miss,' she said. 'Don't let them take me.'

But I needed to get her to calm down.

I sat her down on a chair. I got her to focus on me, on her breathing.

'OK, I want you to breathe out with me, like this...'
She followed.

'And then in again, like this…'

Her breathing calmed.

'Whatever has happened, it's going to be fine,' I said. 'We're here with you.'

But over my shoulder she spotted the two uniformed officers approaching. In a second, all my hard work was undone. She was off again, shouting and swearing up and down the corridors.

'I ain't telling you nothing!'

'Gemma,' I shouted, catching up with her again, but my usual ability to get through to her failed me. 'Just shut up and calm down. They only want to talk to you.'

But at that point they started speaking into their radios again. I heard them say: 'The suspect is coming in.'

They stepped towards her. 'You're going to have to come with us to the police station,' they said.

Gemma was shaking her head furiously, clinging to me, squeezing my wrist so tightly, as if I were her only lifebuoy in this storm. The officers pushed on further, they got hold of her, made to handcuff her arms behind her back.

'She's just a child,' I pleaded again, tears reaching my own eyes.

But they ignored me. They were pulling her away from me. I felt something tear inside my wrist. I resisted the urge to cry out.

'Don't let them take me, miss,' Gemma said, her eyes pleading. 'Miss, please.'

But the two police officers were overwhelming us both. I tried to keep hold of her, but they were just too strong.

'Miss!' she cried, as they cuffed her and marched her off the school site. I followed them, and from the door I saw Gemma's foster mum getting into the back of the police car beside her, moments before they drove away.

At home that night, I told John everything. He listened while applying ice to my wrist. It was swollen and bruised, the pads of Gemma's fingertips faintly visible. My GP confirmed that it was a sprain. My pain was nothing compared to my worry about what had happened to Gemma. She didn't turn up at school the next day, or the one after that. The corridors felt quieter without her volcanic temper, her explosions – both good and bad. I never heard what happened to Gemma. I never saw her again. As teachers, of course we get attached to pupils – we invest our time and energy in their lives. There is not one child that comes through our school that we do not try to make a lasting impression on. But part of our job is also letting go. You never forget kids like Gemma.

As a younger teacher, I know I felt that I could change the world, and it can be one of the hardest lessons to learn that we cannot save every child. There is no choice but to move on, but these pupils and their experiences stay with you, and their stories go into your metaphorical teachers' handbook that you keep with you throughout your career. But where one child you couldn't save has left your care, another ten who need your attention wait in their place.

My friend sent me a cartoon the other day, of a mother talking to her young daughter. The mother is saying: 'When you grow up, I want you to be assertive, independent and strong-willed, but while you're a kid, I want you to be passive, pliable and obedient.'

It reminded me of Gemma, and how I was able to guide her through many situations, simply because we had built up that rapport through friendly chats at breakfast club, or passing in the school corridors. Ultimately her life had taken its own course. I had to learn to accept that I can't help every child, but I fail to see how a policy of silencing children can ever hope to get us closer to making a difference in their lives. How can this teach them how to interact at university, or in the workplace, to fight for their place for a job? If you teach kids that it's wrong to talk, how will you get them to confide in you? I've found in my school that students talk because they trust us, because we're not the police, because we are there to hear their side. We're able to help them by having a conversation, by saying, 'Have you thought about this?' or telling them they're making a mistake – like I did on many occasions with Gemma. We won't be able to have those conversations with kids if we are constantly reprimanding them for talking or rewarding them for silence. They will feel isolated in their own lives. They will feel more alone than they might have done already.

Eight

Our community is a heady and colourful mix of cultures, and our everyday teaching – away from the curriculum – embraces those differences between us and focuses on fostering a mutual respect among our students, helping them to value one another's backgrounds, to learn about them, to constantly be curious. Our school calendar is organised around a Christian one, but only 13 per cent of the students at Alperton Community School describe themselves as Christian. Instead our school is made up of at least six different faiths, each celebrating their own religious feasts and holidays. During Diwali our school is almost empty of both staff and pupils – attendance drops by about 80 per cent – so much so that we start to ask ourselves whether we can stay open. It has always been a good reminder for me that the emphasis should not be on students' comprehension of the British culture, but the teachers' understanding of the students' cultures. At my school, after all, I am the one who is outnumbered,

and so in that way, it is often the students who have something to teach me.

Within the first couple of years of being at the school, I had learned about Hindu gods and goddesses, their beauty and colour. One year the theme for the GCSE art exam was 'Above and Below', which made perfect sense for exploring topics such as the sky, the planets, earth, heaven and hell. Many students completed drawings of gods and goddesses, or sketches of their own little temples at home. Students loved it when I took time to learn a little about their culture; I saw their eyes light up when I talked about Lakshmi or Ganesh from Hinduism, or Muhammad, or the importance of masks in African culture. One class of mine created their own masks from clay. The room looked amazing afterwards with all of the masks hanging from the ceiling by the window, twisting in the sunlight. Children feel seen when you acknowledge their interests – just like the rest of us.

I understand from my own background how important it is for migrant communities to hang on to cultural or religious practices. It is a vital part of their identity that they want to pass on to their own children – especially when many of their parents are so far from a place they once called home.

In the Greek culture we fast for Lent, though not to the extent that Muslims do during Ramadan. I have such a huge amount of respect for the students who choose to fast, many of them sticking to their commitment so

strictly that they even refuse to allow water to pass their lips between sunrise and sunset. But when Eid falls in the middle of exam time, this can have a huge impact on their success, which is difficult to witness when they've spent two years working up to that moment. There have been times when students have fainted in classes that are as hot as greenhouses, or when doing PE in 25°C heat. Our medical room can get busy during Ramadan, with children suffering from stomach pains or headaches caused by dehydration. We have often called parents and begged them to give their child permission to have a drink, or something to eat. But more often than not, the parents have already had the same conversations themselves – it's the children who are being so very disciplined. Some of the unruliest boys in the school are much more respectful during religious holidays. Weeks later, when the fights and scuffles start again, I've often reminded them that they've demonstrated that they can control themselves when they want to.

Many cultural practices are an important part of life for our migrant population, but there remain a few that justify no careful tiptoeing around, only intervention.

Afsana Halil's family were from Afghanistan. She was academically average, nowhere near top of the class, but she worked hard enough to get by. She started the school in Year 7 – perhaps fourteen years ago now – and I liked her from day one. She had gorgeous thick, shiny hair and big

eyes, but underneath her beauty she could be an angry and volatile teenager.

One morning after class, Afsana was hanging around the art room as I tidied up. She followed me into the art cupboard, and as she stood there fiddling with her cuffs, I could see there was something she wanted to talk to me about.

'Is everything OK, Afsana?' I asked, as I put some paint back on the shelves.

She bit her lip.

'Miss, I need to talk to you about something.'

I waited while she wrung her hands together, looking over her shoulder to check no one was eavesdropping.

'What is it, Afsana?' I said. 'Has something happened?'

Afsana was a girl who never usually had trouble articulating what was on her mind, but now I watched as she searched herself for the words she needed. She took a deep breath.

'Miss, I've been seeing this boy, yeah? And he's from Pakistan, he goes to another school, and we had sex...'

I put down the last of my paints. 'Are you safe, Afsana? Are you taking precautions?'

'Yeah, I'm fine, miss, it's not that. But my dad found out I was dating a Pakistani boy and now he's saying he's going to take me to a doctor and sew me up... down there.'

For a second I was relieved. I assumed it was an idle threat, of the kind made by parents to keep their unruly

teens under control. I reached out to touch the top of Afsana's shoulder.

'Don't worry, Afsana,' I said. 'He can't do that.'

'But miss, you don't understand – he's so angry, he said he's going to kill me.'

Outside the classroom, I could hear the chatter of students lining up before the end of break. We didn't have enough time to talk and I could see she was really worried. I told her to come and see me in my office at lunchtime. There we'd be able to talk quietly, and I could convince her she wasn't in harm's way.

'Promise you'll come,' I said as she left for her next class.

She nodded quickly.

Before Afsana arrived at lunch, I had a quick catch-up with Annette, the pastoral care manager I shared an office with. I told her what Afsana had said to me that morning.

'I told her not to worry, that her father can't do anything like that…'

But Annette shook her head.

'Andria,' she said. 'He can and he may well do.'

'What are you talking about?' I replied.

That was the first time I heard about female genital mutilation (FGM), a procedure where the female genitals are deliberately cut, injured or changed, without medical reason. It involves the removal of the clitoris, and the narrowing of the vaginal opening by creating a seal, formed by cutting and repositioning the labia, leaving

girls with a tiny hole at the bottom through which to pee and menstruate.

'It's a way of guaranteeing they're not sexually active,' Annette told me. 'In some countries it's the only thing that will secure a girl for marriage.'

I could feel all the colour drain from my face – but there was Afsana's gentle knock at the office door. This was all new to me: never had I imagined that a practice so brutal could happen anywhere in the world, let alone in this country. But in those whispered few seconds before we invited Afsana into the room, Annette had assured me that it did. I had just enough time to pull myself together as I motioned for Afsana to sit down.

'Can you repeat everything to Annette that you told me earlier?' I asked Afsana. 'We need to know everything that your dad said to you.'

With thirty years' more experience than me, Annette knew which questions to ask, and she quickly established just how afraid this sixteen-year-old girl was of her father. Afsana told her everything, in much more detail than she had told me, and as she did, her story took on greater significance and concern, knowing that there was a very real risk of Afsana's father carrying out his threats.

We asked her to wait outside the room while we discussed next steps. Annette told me that social services and the police would need to get involved. I knew I had to make the call to the senior leadership team (SLT), but I hesitated a second before I picked up the phone,

knowing that once I made that call she would not be going home to her family that evening – or perhaps ever.

The full impact of what I had heard that day hit me. Afsana's confession meant that she was in serious danger from the only people she thought she could truly trust. I have learned since that this is the same dilemma faced by every single professional who has to report the risk of this kind of abuse – the fact that to deal with it you must remove the child from everything that they know and love. Such practices may be so ingrained in a family's culture that even the parents themselves do not realise the gravity of their actions, because exactly the same may have been done to them. But in that moment, there was no room to consider the weight of all of this. There was only Afsana's safety. I made the call.

There is safety to be found in what we already know; at least, that is probably the view of the migrant culture. Outside of that the world is fraught with danger and the unknown. That insecurity breeds fear. As a child I lived in multicultural London, and we walked every day among a sea of faces that looked nothing like our own, yet none of these were faces that I was encouraged to fall in love with – I was taught to believe from a very young age that the best Greek girls grow up to marry Greek boys. My destiny was set in stone before either of my parents had boarded a plane or boat to this country – my future decided from their past.

My parents never judged other people's marriages; they just made clear what they expected for me. My mother impressed on me the stories of fallen girls who had been disowned by their families. It wasn't so much what they said to me explicitly as what I understood intuitively.

I met John in the gym where he was one of the instructors. I'd left university by then and was living back home with Mum and Dad. We got to know each other over the months – hellos over dumb-bells and smiles across running machines – until we went on a date and I realised that he was someone I could easily fall in love with. John was from Zimbabwe, and he had only been in the UK for a couple of years. He was here, like many migrants, in search of a better life, and to make money to send home to his family. He had such a huge sense of responsibility and a long list of relatives, and each week he sent every spare penny he had back home to pay for the education of his niece and nephew, his mother's hospital bills, a funeral, or electricity.

I had to be honest and tell John the truth: that while his was a hand I would long to hold on to, the colour of that hand was considered the wrong one by my parents.

We tried to stay apart, but it was impossible, and so we saw each other in secret for four long years before I missed a period and woke up the next morning with a ring on my finger that John had placed there overnight.

My parents were furious, just as I knew they would be. My father said little and my mother too much. She

wondered aloud what people at church would say, and I told her to tell them that whatever it was, they could say it again, only this time to my face.

'Don't worry, they'll come around,' John said, squeezing my hand.

My father's disappointment was palpable, his blessing too hard to summon.

But our daughter Sophia was born nine months later, and fifteen more after that along came Anna Maria. In time my father and John became the friends I always knew they would be – though it took us another ten years to finally get around to getting married.

When Afsana's father arrived at school to pick her up that afternoon, Afsana was sitting in our office rather than waiting outside for him.

'Miss, my dad keeps calling me,' she said, showing me the missed calls on her phone.

'Tell your dad you're in a meeting with us,' I told her, trying to buy time while we heard back from social services.

A few minutes later, the assistant head teacher arrived in our office.

'Afsana,' he said, gently. 'I've just spoken to your father and I've told him that you will not be going home with him today.'

Afsana looked frantically between us.

'What do you mean?' she said.

'We've informed your father what you disclosed to us today and we've explained to him that, as a result, we're concerned about your safety at home—'

'But I am safe… Miss said, they can't, they don't—'

The assistant head continued: 'Afsana, the police and a social worker are on their way to the school, and we're awaiting instructions from them as to how we're going to keep you safe—'

But she was already up out of her seat, heading for the door. The assistant head beat her to it, blocking her path.

'It's OK,' I told Afsana. 'We've got to do this.'

But the full weight of her disclosure was dawning on her, the fact that she would not be going home to her mum and dad. She looked at all of us in that room as if she hated us, and I understood why.

'Afsana, you have to snap out of this,' Annette said, a harder edge to her voice. 'This is what could happen to you if you go home. In my old school there was a girl who was cut by her parents and she died because it became infected. Is this what you want to happen to you?'

Afsana was inconsolable.

I held on to her, but I knew it wasn't me she wanted in that moment – it was her mum. But her mum could not guarantee her daughter's safety. I repeated to myself over and over that this was for the best, but it never felt like it for a second.

Since that day FGM staff training has become more common in schools. I remember some of the first warning signs we were taught: the girl whose personality undergoes a massive change, who becomes quieter, more withdrawn, who spends longer going to the toilet, or walks slightly differently, or has recurrent high temperatures for no apparent reason. I was horrified then to think back and remember girls who I now think may have undergone FGM. I wish I had known then what to look out for. Suddenly it made sense why certain girls, who had been set to achieve A grades, had returned to school after the holidays only to do so poorly in their exams.

A report published by the NSPCC in 2017 revealed that the borough of Brent has the highest number of cases of FGM in the capital. Between April 2015 and April 2016 there were 325 reported cases of FGM – the third highest in the country after Birmingham and Bristol. This is not a practice that some migrants leave in their home countries when they arrive in the UK; it is one that they can bring with them. It is kept behind closed doors, but it is and has been illegal in this country for more than thirty years. It is not a cultural issue, but a safety one.

According to Home Office statistics, schools accounted for the highest number of all individuals referred to Prevent, a programme created for those at risk of radicalisation. Out of 5,738 individuals who started the programme, 33

per cent of those referrals came from schools. There was a time a few years ago when our concerns about the radicalisation of students in our school centred on Islamic extremism, but more recently we have noticed a rise in pupils with sympathies towards far-right extremism. This is also reflected in the government figures, with right-wing radicalisation accounting for the highest proportion (45 per cent) of all referrals.

Jakub was one such boy who we had these concerns about. I taught Jakub in Year 7 when he arrived as a new year intake. He stood out in class simply because he looked so different from everyone else, with his fair skin and blue eyes. His family had migrated to London from Poland. He was a willing student – almost too willing. I noticed after a while his constant need for attention: singing out loud in class, dropping a pen, always putting his hand up to answer a question. His desire to be teachers' pet seemed out of keeping with most boys of his age. Not that it rang any serious alarm bells at that time, but the further he went through school, the more his apparent confidence grew. On playground duty in Year 8, I saw him teasing a little Gujarati boy.

'Hello Jakub,' I said, walking over to check everything was OK.

He let go of the boy instantly.

'Miss, he started having a go at me,' he said, pointing to the Indian boy, who looked bemused as he straightened his own roughed-up collar and flattened his hair back down.

I raised an eyebrow and sent them on their separate ways. I watched Jakub as he walked away. It was obvious that school life wasn't easy for him: it would be hard in a school like ours for him to find anyone with a similar background or cultural beliefs, and that can make a child feel isolated. Although many children excel in these environments, others find it more difficult, and a lot comes down to the messages they are receiving at home. It can be hard for migrant parents to feel welcome in Britain. A multicultural environment comes with its own pressures. Often adults can be fighting for work, and some employers prefer to employ those of their own nationalities, suppliers prefer to sell to their own, buyers prefer to buy from them. Money is tight, and so are tensions. It's no wonder that attitudes overheard at home can spill over into playgrounds, but as teachers, we have a duty to stamp out any kind of racism or bigotry, to remind pupils that we are a community.

The thing that worried me most about Jakub as he went through the school was that in an institution where he was a minority he was also fearless. By then I had been promoted to the senior leadership team and so I often heard that he'd been thrown out of class, that his temper could flare, that he was unpredictable. It also became more noticeable that he was targeting students who had a different skin colour from his own, and more worrying was the language he used towards them – he got into a fight with a black boy because he called him a monkey.

The boy punched him, but Jakub was unrepentant. It was time to speak to his parents.

As teachers we always hope that parents will back us up. We are, after all, only attempting to ease their child's path through school. But sometimes the parents can be at the heart of the problem, and there is little we can do to educate them. Jakub's parents were a case in point. Like many, they said all the right things – that they would speak to their son at home about his attitude, nodding when we told them that we were a secular community school. But it was clear that they couldn't see what the problem was. And their son's attitude did not improve.

School staff have been guided over the last few years in how to spot neo-Nazi extremism. We have noticed more swastikas spray-painted on walls and bus stops around our community, and have found them doodled into students' notebooks. We've been taught to keep an eye on the student who suddenly shaves his head, and not only because he is a threat to himself and others inside the school, but he is also at risk of being recruited outside of it. Boys like Jakub, so eager to find their tribe, so keen to be liked, are more at risk of being groomed by right-wing extremists.

There are fewer safe spaces for teenagers these days; the community centres and projects that once catered for them no longer exist, and they are too young or can't afford to go to the gym. Instead they hang around on streets and estates that are not safe for them.

The lure of being protected by a gang can be appealing, and boys are most susceptible; males make up 87 per cent of referrals made to Prevent. Boys can be seduced by the freedom that these gangs appear to have – the money, the bikes, the phones. They offer protection, or a place where the kids will be accepted. The psychology of how extremist organisations groom young people is terrifying, and if this is going on outside of school, there is little teachers can do to stop it. Instead we're trained to notice when it becomes apparent within our school gates, and that's what happened with Jakub.

Things came to a head when Jakub got into a fight with a Somali boy. Jakub had told him his parents came from apes and the boy had punched him. Both sets of parents were called into the school; both boys were suspended. Jakub's parents did not understand why their son was being punished so severely.

'It was Jakub who got punched,' his father tried to explain to us, not understanding the gravity of what his son had said to provoke the boy.

Jakub was back at school a few weeks later, and a couple of months after that there was yet another incident. His confidence about making racist remarks was the worrying thing; it was clear there was a deep-set belief in him and he could not control it enough to keep it inside. He was so sure of these beliefs that he was not afraid of the other kids ganging up on him, which meant he did not understand the danger he was putting himself

in, and we knew as a school that someone was going to get seriously hurt.

Jakub was referred to Prevent. He was moved out of our school and into a pupil referral unit. We don't know what happened to Jakub after he left us because his case became confidential. I only hope the Prevent programme was useful for him.

More and more these days, our jobs as teachers stretch further in all different directions. It is never just a case of helping our students to learn our subjects. PE teachers are trained to look for signs of abuse as their students change into sportswear – the bruises hiding out of plain sight, a flash of purple or blue on the skin, or rapid weight loss a sign that these kids are coping with more at home than they should have to. But the government doesn't want to know about the health and well-being of our children, about the real crises they live with day in, day out. Instead ministers want to know why exam results are down, what teachers can do to improve their performance, whether resources or budgets are being misspent. They seem to have very little idea what those of us on the ground are dealing with every single day, and how so little of it fits into their tick-box approach to education.

Nine

Aaden Mohammed was a child who could do nothing wrong in his mother's eyes. His mother was raising her son as a single parent. He was a good Muslim boy, both her son and – without a father figure – the head of the family. Mrs Mohammed would rarely hear criticism about him. At parents' evening I told her gently that her son needed to work harder, but she refused to hear a word against him. I saw him grow in the chair beside her, a smirk stretching across his face, but I knew she was doing him no favours.

The first time I called her at home her son was still in Year 7.

I explained that Aaden was behind on his English homework, that he wasn't paying attention in class, that we were concerned about his lack of progress.

'It's all that English teacher's fault,' Mrs Mohammed told me. 'She is so rude to my son.'

When I eventually put the phone down, the sound of Aaden, not his mother, was ringing in my ears. I knew

she was swallowing everything that he came home from school telling her. She became the mother I dreaded calling. So many times over five long years we were at loggerheads. If Aaden got into a fight, it was always another student's fault. If he didn't hand in his homework, she blamed his teacher. Meanwhile, every day in school we tried to get through to him.

Aaden was in Year 11 when I got the phone call that changed everything. When I answered the phone in my office and heard Mrs Mohammed's voice, I tensed instantly. Her son was still performing badly: he was barely able to concentrate in class, was not reaching expectations in any of his subjects, and had dozens of assignments outstanding. But when she spoke, her voice was softer than usual.

'I need your help,' she said.

Mrs Mohammed came into school the next day. She sat down in my office, more vulnerable than I had seen her before. She gripped her hands tightly in her lap.

'How can I help you?' I asked her.

'My son is addicted to his PlayStation,' she said.

For a moment I stared at her. There were plenty of parents who could say the same. Inside, I was ready to dismiss her fears – surely the simple answer was to remove it from him?

'Every day he comes home from school, he doesn't eat, he just goes upstairs, locks his bedroom door and plays on his PlayStation,' she said.

'But he should be doing his homework,' I said. 'Why do you let him go to his room?'

She started crying, twisting the material of her abaya around her fingers.

'Every time I take the PlayStation away from him, he starts attacking me,' she said. 'He hits me until I give it back. I don't know what to do. I need you to help me. My son is addicted.'

For a moment I sat speechless. This was a mother I had locked horns with dozens of times over the last five school years; every time I had reached out to her to help me control her son in school, she had resisted. But now she needed help from me. This woman lived in fear of the son she had loved and protected his entire life. But I knew instinctively she would never let me involve the police – that wasn't why she had come to me. Right then she just needed me to listen and offer support.

'He is addicted,' she said again. 'It's like taking heroin from a drug addict when I take his PlayStation away.'

'You need to speak to your GP about this,' I told her. 'If he is behaving like this then you're right, he does have an addiction.'

But she was in no fit state to speak to her doctor. I decided to take matters into my own hands. I left the room and went to find Aaden in his class. I brought him back into the room and saw how his mother looked afraid. He shifted in the seat, embarrassed to see his mother so undone in front of him. I repeated to him

what his mother had told me. I saw the look he gave her in return, the same shame I wanted him to feel.

'Can you not get off your device?' I asked him.

'I ain't addicted, miss,' he insisted.

'Really?' I said, glancing again at his mother. 'Tell me, when you go home from school, what do you do?'

He repeated what she had said, how he played games on his PlayStation up in his room.

'And how long do you play for?' I asked him. 'What do you do when your mother wants you to come off the device?'

'I come off when I like,' he said, suddenly more defiant.

It was then I saw something of the resistance that his mother saw. In schools we see the results of children allowed to stay up all night gaming. We see the fatigue written across their faces each day as they try to concentrate in class, or get irritable with their peers. We see how they switch off, how anything that is not triggering that reward system in their brain is unable to get through. We see the fact that homework is sacrificed for just one more hour on their devices – an hour that turns into two, three, four. There have been concerns raised about the effect that gaming devices have on a child's developing brain. The human brain does not reach full maturity until people are twenty-five. A California State University study has shown that addictive video games such as *Fortnite* can have a similar effect on children's brains as drug abuse

and alcoholism. MRI scans revealed that the impulsive part of the brain – the amygdala-striatal system – was not only more sensitive in those who spend hours gaming or on social media, but smaller. Children are flooding their developing brain with hits of dopamine – no wonder the school day cannot hold their attention. It is boring in comparison, the pace is slower – they are used to more stimulation. Heavy use of video games in thirteen- to fifteen-year-olds has even been linked to an increased likelihood of drug misuse. And yet parents feel their kids are safer upstairs in their bedrooms on devices than out in the real world.

'What are you doing with your life, Aaden?' I said, my voice rising up from my chest. 'You're assaulting your mum, the woman who has given you life, who has provided you with a home. You should be ashamed of yourself.'

He started crying then, hiding his head in his hands, sniffing into his palms, wiping his tears on the sleeve of his shirt. But I wasn't finished with him.

'This year you are due to sit your GCSEs,' I said. 'How are you going to do that if you are up all night gaming?'

No answer.

I continued: 'This is what your mother is going to do: she is going to go home now and take your PlayStation from your room and put it in the boot of her car. You can have three hours on your PlayStation every Sunday. Three hours once a week, and that is it.

'If you do not comply with this, I will cancel your examinations,' I threatened. He didn't need to know that would be impossible. 'Do you understand me?'

He looked up from his hands and said in a small voice: 'Yes, miss.'

For some reason, sometimes students will listen to teachers more than they listen to their parents. My plan for the pair of them must have worked because I did not hear any more complaints from Mrs Mohammed, and there was a noticeable improvement in Aaden's work, though not quite enough for him to catch up on all the work he'd missed. Perhaps that meeting with me gave that mother the strength to stand up to her son. I hope so.

Aaden's is an extreme case, but it is not the first time that I have had to show a parent how to discipline their child. More often I am noticing parents who have abdicated responsibility for their child-rearing, surrendering their child to the care of a device instead. Some parents are even convinced it is a good thing.

One of my students, Lucas, was similar to Aaden in that whatever homework he was set, he would never hand it in. One parents' evening, I pulled his mum aside about it.

'I love your son,' I said, 'he's a great kid, but he never does his homework.'

'Well, he doesn't have time,' she said. 'He spends so much time gaming. He has forty thousand subscribers on his YouTube channel now; people are blown away by his

designs on Minecraft – he's even started making money from it.'

Lucas stood beside her nodding.

'I'm going to be a professional gamer when I leave school, miss,' he said.

Beside him again, his mother nodded.

'And you're OK with this?' I asked her. 'Because I'm not.'

'But he's doing well on his gaming,' she said. 'That's his future.'

I couldn't believe what I was hearing.

'But in a few years he will be sitting exams,' I said. 'How will he do that if he hasn't studied?'

There was no getting through to them; as far as his mum was concerned, her son would go into gaming. His career had already been decided. School was unimportant.

I hear the kids in the corridor making plans for after school, the hustle and bustle as they arrange who is going to be online an hour after school finishes. Many parents have a fear of their child being outside of the home and feel instead that their children are safer in their bedrooms. But do they really know what they're doing up there? Or who they are talking to?

Who would want to be a teenager today? My secondary-school life was so different from what I witness today. I worry about my two daughters – who are now twelve and ten – growing up with the influence of social media.

I see for myself, in class, just how much this impacts on school life. Ask any teacher across the world how they feel about schoolchildren having mobile phones and they will roll their eyes and sigh and look heavenwards, because we are all exasperated by the influence that they have on students.

When I was at school we had nothing like that to worry about. We were not stars in our own small universes then; we had not created profiles on Instagram, Facebook, Snapchat or TikTok, because they did not exist. The celebrities were the ones we watched on *Top of the Pops* each week, a show that mums and dads enjoyed alongside us. The stars were the ones whose posters covered our bedroom walls – Bros, Duran Duran, and of course, in my house, George Michael, because he was Greek. We aspired to be the Fresh Prince of Bel Air, or someone off *EastEnders*.

I was sporty and belonged to every team in my secondary girls' school. I pushed myself, sweating as I dribbled a football around the pitch, unbothered by how I looked, more focused and concerned with beating the other team. We did not need to doctor our photographs to like our faces more. We didn't spend hours watching make-up tutorials on YouTube. We didn't worry about our bodies in the same way kids do now – there was no Kim Kardashian to remind us our bums were too small or our boobs not big enough – or feel bad that we didn't have the money to buy all the things that would make us

look cool. Kids today are exposed constantly to what the idea of perfection should be.

We didn't have personal phones: instead, the home phone was shared by everyone in the house, an extension lead reaching all the way up to your bedroom – if you were lucky. Our minds were not flooded by social-media influencers who claimed to give us more confidence but instead showed us how to look like everyone else, in reality leaving us feeling worthless because we didn't have enough followers or likes. There was no one idea of perfection, but a thousand ways to be.

We did not have acrylic put on our nails; we did not pump filler into our lips. We did not think that we needed to behave like a porn star to get – or even keep – a boyfriend. We exercised to keep fit, not to get a six-pack. And there wasn't the pressure to perform at school the way there is now. We sat the same number of subjects, but we had a third of the exam papers.

I worry for my girls in a way I know my parents didn't have to worry for me. Every week I tell parents that they should be monitoring their child's time on devices, but I know that hasn't always been the case in my own parenting. I have rules for my girls – no iPad before 7 p.m., all devices off by nine. But I know that sometimes I'm busy with my own phone, and it might be 10 p.m. before I remind them to get into bed. I feel like a hypocrite sometimes when I criticise parents for allowing their children to play on video games, or ask them how

often they look at their own phones – remembering how many times my husband has reminded me to put my own phone away when we're meant to be enjoying family time.

All parents have jobs to do, and all come home exhausted. We all need to cook and clean, and we all want an easy life. But sometimes I wonder what it is doing to our children's brains when we hand them a device to keep them happy instead of sitting down with them ourselves. I dread the day when my kids ask me for a PlayStation because I know that they are more addictive than drugs.

When I was a teenager I saw my mother's face, not the back of her phone. I felt loved and safe and confident because I had her attention; I was not competing for it with some device.

When I was a child I was out on my bike all day, only coming home when I was hungry or I'd grazed my knee. How are we raising our children if they're safer in their bedrooms than out in the fresh air?

Forget being a child – who would want to be a parent today?

Raheebah Bhatti burst into our school like a cannonball in Year 10. She was a feisty fifteen-year-old, seemingly afraid of nothing and no one, with a mouth to back up her attitude. She had been transferred to our school in what is referred to as a 'managed move', which meant

there were serious problems at the last school, though to give her the chance of a clean slate, we were not told many facts, just the very basics.

She wore her hair on the top of her head in a tight bun, and gelled everything in between so she never had a strand out of place. She wore a plain black knitted jumper and skirt, nothing branded with the school logo, and she only slipped her tie on once she'd come through the school gates. She preferred the company of boys, quickly assessing who were the alpha males of the year and sidling up to them. This got the hackles up of the girls whose boyfriends she was flirting with – not that she seemed bothered if she upset them – and, like that, just as quickly as she had at her last school, she made enemies at Alperton. She was in trouble from day one. Raheebah didn't try and blend in, but aimed to stand out. She was fearless, and nothing seemed to crack that armour she wore. I was surprised then, one afternoon, long after classes had finished, to find her loitering outside the year room.

I popped my head out of the door.

'You're here late, Raheebah,' I said. 'Is there anything you want to talk to me about?'

She turned around, giving me a look up and down.

'No,' she shrugged, 'why would I want to talk to you?'

I didn't react, just went back into my office and continued marking work, but ten minutes later she appeared in my doorway. She chewed on her gel nails, her eyes dipping to the floor.

'Are you sure everything is OK?' I asked.

She didn't say anything, but she didn't leave, either.

'Raheebah, are you in some sort of trouble?'

She nodded silently. It was unusual to witness this feisty girl so anxious – something must be seriously wrong. I called her in and asked her to sit down.

'Do you want to tell me what's going on?' I asked.

When she started to speak, she didn't hold anything back. She told me the whole story of what had occurred at her previous school. She hated home, hated the way her father spoke to her mother, how she refused to stand up to him, so she spent as little time there as she could. On the streets she fell in with a bad crowd, a group of boys who passed her round for sexual favours. She had nowhere else to go, and she had little respect for herself, so what did it matter what they did to her? – or at least that's how she felt. But one boy had filmed her without her knowledge, and videos of her performing sex acts had been passed around the school. Raheebah was forced to move to escape her past – particularly the boy's girlfriend, who had a gang of friends all wanting to hurt Raheebah.

'But now she's found out I'm here and they're waiting for me outside,' Raheebah explained. 'They're gonna kill me, miss.'

It was the first time, behind all the bluster and bravado, that I saw Raheebah for who she was – a frightened and vulnerable girl.

I made a call on my walkie-talkie to the security team and asked them to go outside and check surreptitiously for signs of any gangs waiting for Raheebah. The call came back that there was a big gang of girls from another school waiting by the bus stop. I told them to call the police to see if they could move them on. But there was no way I could let Raheebah leave now. She waited in my office. I saw how her eyes flickered across my desk, landing on the photographs of my daughters.

The hands made their way around the clock: 5 p.m... 6 p.m... 7 p.m. The caretaker wanted to lock up the school. I was trying to get hold of her parents to pick her up, but her father was at work and her mother didn't have a car.

'It's no good,' I said. 'I'm going to have to drive you home myself.'

I called my head teacher to get permission.

We walked across the car park in the dark, my eyes darting this way and that – almost as nervous as Raheebah. We made it to the car, locked ourselves in, and as I put my key in the ignition, Raheebah shrunk down in the back seat so no one would spot her through the window as we drove out of the school gates.

This was not the first time that I'd been forced to take a pupil home myself to keep them safe. Every day our students live with the threat of gangs from neighbouring schools. Once, a gang of men wearing bandanas stormed the park that we use for PE to target one of our pupils.

Luckily the teachers stood between them and the kids to keep them from harm's way. Another time we had heard a rumour that there might be trouble from a gang after school, and as we were seeing our students safely onto their buses, a group of teenagers I didn't recognise arrived on bikes, equipped with metal chains around their waists that they started to take off. I could do nothing but herd the pupils onto the bus and wait until the call of police sirens forced them to turn on their heels. Sometimes I've even taken the bus with students to ensure they get home safely.

Raheebah lived on a council estate that I drove by every day. We pulled into her street in my brand new Honda Civic. I knew these homes and the poverty that went hand in hand with them. As we got out of my car, a group of young boys crowded round on their BMX bikes, sucking on their teeth at the sight of my alloys and black spoiler.

'It's this way, miss,' Raheebah said, throwing back her shoulders and sticking out her chest, that same faux confidence returning to her as she led me through a labyrinth of streets to her own front door.

Her mother opened the door – she was a small, young woman, her hair covered in a hijab, and modern trainers on her feet. She barely spoke English but was warm and welcoming, awash with relief that her daughter was home safely. She ushered me into a smart, clean living room, the floor covered in Persian rugs and quotes from the Quran stitched in colourful threads framed on the

wall. Raheebah's father worked as a minicab driver; he was already out picking up fares when I arrived. Her mother brought in a silver-coloured tray, complete with tea glasses in tiny saucers and a selection of fruit and biscuits. She poured me a drink and urged me to sit down. In broken English she managed to get across to me how worried she'd been about her daughter. Safe and sound now, Raheebah brushed off her mother's fears, snapping at her curtly. But I could see just what this mother had been through, how much she had wanted her daughter to have a new start. I took her hands in mine as I left.

'Don't worry,' I said. 'I'll pick Raheebah up in the morning and bring her home each night.'

'Thank you, thank you,' she said.

Each morning Raheebah would come out of her front door when I pulled up in my car. I used those drives to school and back to get to know her better, to persuade her away from the life that she was drawn to, to help her realise that there was another way.

'You've got to start knowing when to shut up, Raheebah,' I told her. 'It's always your mouth that gets you into trouble.'

'I know, miss,' she said, but each day on the drive home from school, the sound of the scraps and squabbles Raheebah had had that day with some other student were ringing in my ears.

In the end though, it was never going to be my decision as to what the future would hold for Raheebah. In some ways

it wasn't hers, either. I provided a taxi service for Raheebah for a week, but by the end of it the school decided to send her back to her previous school. It wasn't just the trouble she was getting into, but the danger she was bringing to other pupils by antagonising students from another school. It was a security risk to the other children to have gangs of kids waiting outside the school gates each day.

Her mum came into school to thank me on Raheebah's very last day. As I hugged her, I felt her disappointment that this had not been the new start for Raheebah that she had longed for.

'You try your best,' she said, though I wasn't sure which of us she was referring to.

We never heard what happened to Raheebah after that. Would she have been able to turn her life around? Who knows? Thanks to social media it is impossible these days for children's mistakes not to follow them. More and more the bread and butter of our teaching work is spent resolving conflicts that have started in students' bedrooms on WhatsApp or Facebook and then spilled into our school day. It's hard not to conclude that social media is not good for our children. A 2017 survey jointly carried out by the Royal Society for Public Health and the Young Health Movement found that social media increased the feelings of inadequacy and anxiety in young people aged between fourteen and twenty-four. Childline has seen an 87 per cent increase in calls concerning cyberbullying. Squabbles that were once left

in the playground and forgotten about by the next day go home with children, and continue up in their bedrooms, thanks to social media – there is no escape. I don't need statistics to tell me that social media is having a bad effect on today's children; I see it every day in class, from cases like Raheebah's to the girls susceptible to self-harming because of the unsafe images they are exposed to online.

Teachers already have enough to deal with each day, and yet, if not us, who will help today's teenagers navigate the uncharted waters of social media? Who will explain the danger of these devices, the harm they can cause and how young people can deal with it? Most children would rather keep these problems to themselves than risk having their devices taken off them. But as a society we are placing a huge burden on these children. It feels impossible to fix something so intangible, something we cannot see. But surely it is not up to teachers alone to deal with the impact of social media. Not when we are already so overwhelmed.

Ten

Teaching, for many, is never just a job. It is a calling, a desire to create change where it really matters, to help shape the next generation, to see the ripple effect of the values and skills you instil in a child swell to make a bigger difference in society itself. But it's not suited to everyone, and there can be a gulf of difference between perceived ideas of teaching and the reality.

In 2009 Martin Newton was one of Alperton Community School's intake of NQTs. His department was science, and his enthusiasm for his subject was infectious. The students loved him. I often saw them arriving at or departing from his class, always smiling, full of energy. Martin should have been a brilliant teacher. But something was missing.

It took a group of GCSE students to alert me to this. They found me in the playground one lunchtime.

'Miss, we need to talk to you,' the tallest – and bravest – of them said.

'Is everything OK?' I asked.

'Not really,' the same boy said. 'It's Mr Newton... we love him, miss, he's such a nice guy, yeah? But we're worried we ain't learning nothing.'

I was aware that one of my eyebrows had raised. The students twisted uncomfortably inside their coats. It was clear it had taken real confidence for them to come and give me this information, and they obviously felt they were betraying a teacher they really liked.

'Can you tell me a little more about what you mean?' I said.

They started volunteering information, tentatively at first.

'The classes are just chaos, yeah?' one boy said.

'We ain't even sure what we're meant to be learning,' said another.

'Look,' a third said, pulling his science book from his bag, 'I didn't even write any notes coz we didn't learn nothing last week.'

I took the book from him and flicked through. He was right: there were hardly any pages filled and these boys were just months away from sitting their exams. The odd notes they did have in the book trailed off without conclusion. This wasn't the way that Year 11 science students' books were meant to look.

'OK,' I said, reassuring them. 'Thank you for telling me.'

The boys looked relieved.

'But don't tell Mr Newton it was us that said nothing, yeah?' the tallest boy said quickly. 'We don't want him thinking we've grassed him up.'

'It's OK,' I assured them, 'I won't let him know.'

As he was an NQT, it wasn't unusual for me to let Mr Newton know that I was going along to observe his next class of GCSE students. I would never have told him that it had been them who had raised concerns – it was not helpful to the boys or Mr Newton himself to know that, and it could really affect their relationship, so I just checked when the class was on the timetable and let him know I would be there among the students that day.

I went along with an open mind – although I knew just how rare it was for a student to raise concerns that they are not learning and for other staff not to find a problem. I have always found in observing classes that the best way to gauge whether a class is going well is not necessarily to listen to the teacher, but to look at the students – if they have their heads down in concentration, it's usually a good sign. But when I arrived at this class, the students sat with their notebooks open, their pens poised, yet they seemed confused as to what exactly they were meant to be writing in them. The scene that I walked into was indeed chaos, just as the boys had described. Mr Newton had three experiments on the go that he was demonstrating to the kids. I watched from my vantage point while he dashed between them – in one corner

of the room he was dissecting a lung, in another corner he was using a Bunsen burner to demonstrate different metal ions, while over at the back of the room he had a plant, some water and a bright light to help explain photosynthesis. I watched the students as they followed their teacher as he dashed this way and that, their heads trying to keep up as he sprang around the room – they looked like they were watching a game of tennis rather than calmly following a GCSE class.

'Is it always like this?' I whispered to a girl sitting next to me.

'Always,' she said quietly. 'Mr Newton is crazy.'

I asked if I could have a look at her notebook. It was the same as the boys' notebooks, although she had written up some notes that they hadn't. I pointed to them and asked if she'd learned them in class.

'No, miss,' she said, 'I had to go home and look up what Mr Newton was meant to be teaching that day because I couldn't understand in class.'

This was not a good sign.

I turned back to observing the class. I could not fault Mr Newton's enthusiasm – he even jumped on one of the benches to make one point before leaping down again to beckon the children over to the Bunsen burners. They stood around watching as he talked animatedly about what he was demonstrating. But I could not believe what I was seeing. Neither Mr Newton nor any of the students were wearing protective goggles. He had their

attention – there was no denying this – and they seemed excited by what he was showing them, but his lesson was a health-and-safety nightmare. I couldn't take it any more. I went up to Mr Newton discreetly and said: 'I'm afraid I'm going to have to stop this lesson. Would you mind stepping outside for a quick chat?'

He turned off the Bunsen burner and followed me out the room while the rest of the students returned to their seats. I kept my foot inside the door so it didn't close behind us.

Outside in the corridor, he was flustered and apologetic.

'I'm so sorry about that—' he started.

'It's OK,' I said, quietly, 'but do you know why I had to stop that lesson?'

He stared back at me, perhaps unsure where exactly to start.

I started checking the misdemeanours. 'The students weren't wearing goggles; you were climbing on the benches; there were three different experiments going on...'

He wiped his hand over his face.

'What was it exactly you wanted them to learn?' I asked.

'Well, I... erm... '

'Gosh, that was bonkers,' I said, and we both laughed.

I arranged with him that he would come and meet me in my office the following morning. We both left

laughing, but in all honesty, what I had witnessed in that classroom left me incredibly concerned.

Life can feel like a constant stream of impossible choices for women once they become mothers: they need to hold down the job they have worked for their whole lives with the same vigour, while at the same time meeting every one of their baby's needs. To counter that, I worked twice as hard at dispelling any preconceived ideas of how my priorities might change after motherhood – if only to prove to myself I was still that same person inside.

I set my alarm earlier each day, the call of it rousing me from a black night so I could get my baby ready for the day and still beat the students to the school gate. I was lucky that I had a brilliant childminder, and my mum and dad nearby to help whenever I needed it – but there were still days when the two parts of my life collided, and I took Sophia along to half-term interventions, jiggling her on my hip or rocking her inside her pram as I cast my eye over students' work.

Fifteen months after my firstborn, along came Anna Maria. I worked until only a week before I gave birth this time, determined not to miss a minute more of school than I needed to. Not only had I brought another life into the world, but I'd seen my beloved first form class through their GCSEs.

More reshuffles awaited my return to school after my second maternity leave, a turning of the tide that washed

up new opportunities within the senior leadership team. I applied for the new role of achievement director, which made me responsible for the academic attainment and well-being of all Key Stage 3 students – almost 700 of them in total. It was my most challenging role yet, but it was during those years that head teacher Maggie Rafee's dream for the school came true and we were graded as 'outstanding' by Ofsted. We celebrated with a banquet dinner for all the staff, and banners flying outside the school gates. Maggie's leadership had turned a failing school around and lifted the spirits of the whole community. Parents who were once ashamed that their child attended the worst school in the borough now felt proud to send their child to us; ties were straighter, shirts were tucked in – the sense of achievement was infectious. The school stood as a shining beacon, an inspiration to all that it was never too late to be what you might have been.

Three years later it was time for another reshuffle, Maggie being keen, as always, to reinvigorate her teaching staff. I found myself as head of professional development, this time not mentor to the students, but to their teachers. That role was the best thing that happened to me. It meant liaising with other schools to find solutions to our own teaching problems. If there was an issue in the drama department, I could reach out to a lead in another school to help us make it better, or vice versa. I was responsible for all of the NQTs, and even for helping reshape the careers of experienced teachers who somehow found themselves stuck in a rut.

The only sacrifice was less time in the classroom, less time with the children that had always mattered the most. My timetable of teaching was reduced to just 40 per cent of the week, but my rise through the school meant I could make more impact on the students' lives, and so it felt like a price worth paying.

Maggie led our school to become a cooperative academy, which meant that it ceased to be funded by the local authority, and funds were received directly from the government. This gave the school and its governing body many more powers over how the school was run. But after Maggie left the school, an Ofsted inspection three years later saw us falling all the way down to 'requires improvement'. We had all worked so hard, so we wondered how this could have happened.

The new head teacher, Gerard McKenna, was determined we would climb back up that greasy pole. Still responsible for professional development, I searched myself for what I could do to implement change. I introduced 'professional development Mondays', an hour each week when I would design a bespoke development package for all teachers to attend. It sets aside time for teachers to improve their skills, to take more courses, to hear talks from organisations like Prevent, or to attend workshops from exam boards. It also gave us time to experiment with different types of teaching, and to implement action research projects, where we found out what worked well for our school by testing

teaching strategies, ideas and theories on students across the board.

In my role as head of professional development there was no official end to my day; sleep was nature's own boundary to me answering emails or calls well into the night from worried teachers, or those who needed extra mentoring. To me it was natural to give them my mobile number, to insist that they could call any time out of hours, even weekends, and I would bounce a baby and a toddler on my knee while I promised to find them extra training that would reinvigorate their career, or help them prepare for lessons better.

Maybe the teachers finally felt that we were investing in them, as well as the students, but teaching across the whole school became more consistent as a result and students felt more confident that in each classroom they would find the same approach, which meant all they had to do was get on with learning.

I wanted some external validation of how hard we had been working as a school, and applied to the Institute of Education for one of their Professional Development Quality Marks. I worked hard to make sure that everything we did as a school fitted their framework, and that it was support staff as well as teachers who were being developed. The first award we received from the Institute of Education was gold; a year later that was upgraded to platinum – an accolade fewer than ten schools in the country had received. I knew it made a difference for

teachers applying for jobs with us to see that standard mark, that they would feel confident that we were a school that invested in its staff as well as its students. I know it would have made a difference to me.

Two years later, in 2016, we had another Ofsted inspection. This time we were graded as 'good' with 'outstanding' leadership and management. We were on our way back up.

Mr Newton's science lesson had been the last of the school day, and straight afterwards I had a meeting with the rest of the senior leadership team. They could tell from my face when I walked into the conference room that something was very wrong.

'I've just witnessed the weirdest lesson of my entire life,' I said quietly to a couple of the other SLT teachers. One of them worked in the science department, so it gave me the chance to check with her what the curriculum entailed for that year group and if it was ever appropriate to teach in that manner – but I knew already what I'd witnessed was crazy.

My colleagues were brilliant. Much of the meeting was dedicated to helping me dissect how to address Mr Newton, how to raise issues, and the best course forward. We even practised role play so I felt more confident.

The following day I was sitting in my office when I heard Mr Newton's tap at the door. He put his head around it, already looking terrible. He'd obviously had a

chance to reflect overnight and suspected he was going to be reprimanded.

'Come in, Martin. Sit down,' I said, standing to close the door behind him.

He started talking before I had a chance to sit back down.

'I'm sorry, Andria, I know what I did wrong.' He launched into a full explanation of the whole class again. Even hearing how he'd planned it all made my head spin.

'I'm sorry, I just wanted to show you what I could do.'

'But it isn't about me,' I said. 'It isn't even about you. It's about the students.'

He nodded, sighing.

'Martin, I cannot fault your energy or your enthusiasm,' I said. 'But I'm worried that these students are not learning in this kind of environment. You need to stop working at ninety miles per hour and bring it back to two miles per hour.'

He looked down at his lap.

'But I think I've got some ideas to help you.'

Martin listened as I told him what I thought could help. That he needed to work on his planning, that I was going to pair him up with another science teacher, Baashir, who I knew was brilliant at planning lessons and a fantastic teacher.

'You are brilliant with your subject knowledge,' I said. 'We just need to get the thinking right with regards to lesson plans.'

By the time he left, I thought we were both feeling much more positive.

Martin and Baashir started working together over the next couple of months trying to meet the targets on the support plan that I had put into place. I left them to it, aware not to micromanage, but to allow Baashir time and space to show Martin a better way of working and for him to reach the objectives of the support plan. Martin was observed by other members of the SLT team during this time and Baashir kept me up to date with how it was all going.

'He's great when he comes to see me,' he said. 'He has everything planned, he's raring to go and he takes on board all my comments and suggestions. But when I've gone and observed the lesson, in front of the students, he's done the complete opposite of everything we'd discussed.'

I agreed with Baashir that I would go along again to observe one of the lessons – this time with Baashir with me. I was hopeful that after two months of working with Baashir, I was sure to see some improvements.

A few days later we settled down at the back of the classroom as the pupils came filing in. I asked Baashir what the lesson was focusing on that day.

'Photosynthesis,' he said.

But when the teaching started, the lesson bore no resemblance to what Baashir and Martin had discussed. Instead, Martin seemed to be teaching the students about forces and motion – and even that wasn't clear.

At the end of the lesson, I left feeling sick. In my office I sat with my head in my hands. I knew that I was going to have to have a very difficult conversation with Martin, and I knew that what I had to say might even suggest the end of his teaching career. But I had to, for the sake of the students. There have been many times over the years when I have had awkward conversations within the school environment. Some of them are between myself and the students; the more uncomfortable ones occur between myself and parents. But nothing is as difficult as having to tell a colleague that they are failing, that their teaching standards are not good enough. I would rather not have those conversations. But the litmus test for me is always whether I would want my daughters to be taught by that particular teacher. And if the answer is no, that conversation needs to be had.

Back in my office I sat Martin down.

'I'm very sorry to have to say this, Martin, but if you carry on like this, I won't be able to pass your NQT. You have just not made the amount of progress that we expected you to make.'

He seemed in that moment to shrink inside his suit.

'I really think it's time for you to consider your next steps,' I said.

I have observed that in other countries around the world, once teachers qualify as professionals, they are left to their own devices. In some ways I envy them the autonomy, the decision-making and the respect that

seems to go hand in hand with that. In this country, teachers are not trusted in that same way; decisions with regard to grades our GCSE students receive are assessed not by us but by an external examiner. But on the other hand, the fact that teachers are still subject to assessment once they arrive in school and then throughout their professional teaching career means that we keep the quality high. Somebody like Martin should answer to someone, because otherwise it would only be the students that suffer. After leaving teacher-training college, every NQT who enters a school has to pass three terms before they are deemed professionally qualified. If they fail to pass those terms and are put on to a support plan, this appears on the record that follows them throughout their professional life, so when we know a teacher is unlikely to pass, it often makes more sense to flag this up to them so that they can reassess their choices, or get more experience as a supply teacher before completing their official qualification. It is a good way of ensuring that teachers are ready to enter the classroom after completing their teacher training, because every school environment can often be very different from what many PGCE graduates imagine.

It is not unusual to have a high number of people who drop out of the profession altogether during their first year of teaching. According to Department for Education statistics, 15.3 per cent of NQTs who started work in 2017 were no longer in service by the following

year – that means one in seven new teachers quit in their first year, an estimated loss in training costs of around £90 million, according to figures from the Institute for Fiscal Studies. There are many reasons for this: perhaps the particular school that they have gone to work in is not suitable for them, perhaps they don't receive the support they expected once they arrive there, or maybe they are just not prepared for the reality of a school environment.

This was the conversation I needed to have with Martin. He accepted that he needed more experience.

'I'm grateful for your advice,' he said.

'I don't want you to lose faith,' I explained. 'You are charismatic and passionate about science, the students love you and you make learning fun for them, but you're not following the rules of the curriculum.'

The following day he handed in his resignation. It is always a shame to lose a teacher, but we have to think of the students.

Martin contacted me a couple of years later. He had done as I suggested, and got more experience as a supply teacher before going back into a school and passing his NQT. Now he works in a school in south London, where he is as brilliant as I knew he had the potential to be.

In a large school like ours, which has more than 220 members of staff, those awkward conversations are unavoidable. Some teachers – like Martin – make them easier by accepting that you're only making suggestions

to improve their working practice and the experience for the students.

I have been on the receiving end of criticism, so I know how it feels. In my second year of teaching, Ofsted were doing subject-specific inspections, and I had an external examiner come in to observe my art class. Any teacher, no matter how competent, will find the experience of being observed difficult. I spent a lot of time organising my lesson, making sure I had planned everything to perfection. The examiner who arrived at my classroom had a huge beard, and long hair that he tied up in a bun – he definitely looked like an artist to me. After the lesson he told me how much he had enjoyed it.

'But do you realise how much you shriek when you talk?' he said.

'Oh,' I replied. 'No, I didn't realise.'

'Yes,' he continued, checking his notes, 'particularly when you get excited, and you also talk too quickly so some students might not understand everything that you're saying.'

He said many positive things too, but of course, I didn't hear those – it's only human to focus on the criticism. He also mentioned that the photocopies I was using as handouts weren't the best quality. Ever since that day – twelve years ago – I have made sure I've laminated every single one of my handouts.

It hurts to be criticised – whether you're fifteen or fifty – and some teachers handle it worse than the students

themselves. As a result, I have become very mindful of the language I use when I am approaching NQTs. I will suggest they 'have a think about the way they do this, or that'. Or say: 'Why do you think that child is doing that?' I try to help them to unpick the problem themselves. But it doesn't always go to plan.

When Devinder Sangah arrived at the school, I mistook her for a student. She was fresh out of college, dressed in a short black skirt that showed off skinny boot-clad legs, and wearing cool, thick, horn-rimmed glasses. I was about to question her choice of uniform when she introduced herself very confidently as one of the school's new maths teachers.

'Oh, welcome,' I said, shaking her hand, trying to disguise my surprise at her appearance.

Miss Sangah passed her first term as an NQT, although only just. But by the second term, the strain was starting to show. Walking past her classroom one day, I peered in through the window and saw the students in absolute disarray – a few of the boys were up out of their chairs wandering around, some of the girls had turned around at their desks and were chatting to those behind them. There was noise, there was chaos, and Miss Sangah stood at the front writing on the board, her back to the students, seemingly oblivious.

I opened the door and went inside. The boys instantly sat back down on their chairs.

'Hello miss,' I said. 'What are the students learning today?'

'I'm just writing the objectives of the lesson on the board,' she said.

I bent down to look into the book of the student sitting closest to me. He hadn't written anything.

'What are we learning today, John?' I asked.

'Erm, er...' he replied.

'Oh, come on, John,' Miss Sangah said. 'We've just gone through this.'

But it was already obvious to me that if the students didn't know, Miss Sangah had not made herself clear enough.

The following week, I went to observe one of her lessons. I sat at the back and watched as the students arrived, chattering, up and down out of their chairs, Miss Sangah sitting at the front of the class, cross-legged on top of her desk, taking the register and talking with them about last night's *EastEnders* for the first fifteen minutes of the class.

Later on that day in my office, I suggested that she wasn't promoting the best learning environment for the students.

'It's best to start the lesson by getting them to line up quietly outside of the room,' I explained, as her eyes roamed my room. 'Then, when they come into class, if they're still not listening, start writing names on the board.'

'Yeah, I don't believe in disciplining students,' she said.

I stared at her, as if I wasn't quite sure I had heard her correctly, shocked at her confidence.

'I prefer kids to be able to express themselves,' she said, defiantly. 'They are individuals and have the right to be who they are.'

I had come across this perspective in teachers before; some feel that they will get the best out of students by being friends with them, rather than being a professional.

'But the problem is your students are not learning,' I said. 'Teaching can be different, and I don't expect everyone to do it the same – it can be crazy and wild and exciting and experimental – but if I come in, I need to be able to understand what's going on. Your students were not focused; they were completely distracted.'

'That's not really my teaching style,' she said.

I knew I needed to try something else, something clearer.

'I'd like you to follow school policy,' I said. 'If you're not doing this, you are not abiding by procedures and there is inconsistency in their learning.'

She reluctantly agreed and left my office, but I was not convinced I had got through to her. I didn't want to micromanage, so I had a word with her mentor and left it to the two of them to sort out.

But a few weeks later, a couple of the students from her class who had seen me going in and out of the class-room asked if they could have a word.

'We're not learning in this class, miss,' they said.

They were diligent students, and they were worried about the way they were being taught. And there was something else.

'We feel really uncomfortable with the way she dresses,' one of the boys said.

This was more difficult to deal with. There should be an understanding of appropriate dress in schools. The students in class might have been used to older siblings wearing inappropriate clothing, but not their teacher.

I returned to observe the class again, but things had not improved. In fact, they had got worse. Miss Sangah had lost control of the class altogether. Her relaxed, laissez-faire approach meant that the students had no boundaries compared to their other lessons. They saw this as a 'doss' class. Children respond to consistency, and it helps them to learn if all teachers adopt the same policy throughout the school: the same way of disciplining, the same way of marking. If every teacher does this, it helps all the other teachers too, because the students know exactly what is expected from them, and that way, the teacher can focus on learning. But these students had lost respect for Miss Sangah. Not only that, but I sensed a change in her. Her spirit wasn't there any more, she was withdrawing from her own class, and it seemed that she was not enjoying it. Her attendance was also becoming a problem. We decided to track it, and noticed that she was regularly missing on the days she had that particular class. I asked to see her again in my office.

'We've noticed that you're absent from school on the days you have that class,' I told her.

'I can't take it any more,' she said, breaking down. 'I don't like teaching. I thought it would be something else – in training it wasn't like this. It doesn't matter what I do, the students are just not listening to me.'

'Have you tried all the suggestions I made?' I asked her.

'Yes,' she said, 'but nothing worked. They just didn't engage. I don't think I'm going to be a teacher. I'm thinking of leaving the profession.'

I reluctantly felt that she was making the right decision. It could be that our school wasn't right for her, and she could feel more at home in a very niche school, a private school even, or a special school, but a mainstream, inner-city school wasn't right for her. The last I heard, Miss Sangah was working in accountancy in the City.

Many of my sleepless nights have occurred the day before I've had to have a difficult conversation with a colleague, not a student. Teaching is an art form, not everyone can do it, and because it is so personal, because it is just you, almost on a stage, using your personality and skills to persuade a bunch of kids to fall in love with your subject, any criticism can feel very personal. I've met many teachers who are unable to take that criticism. I've had them break down in front of me and blame the students instead of looking at themselves. One teacher, who was under-performing in his subject for years, even accused

me of bullying him, and asked the union to monitor our interactions – luckily I had offered him a lot of help and support to improve his teaching standards, which had all been documented. But it was a stressful experience for both of us.

It is a vital part of the job to keep teachers accountable to their students and keep professional standards high. If bad behaviour goes up in the classroom, the grades go down – it's a very simple equation. It is not fair for the teacher in the next room, who is keeping her class under control, to teach next to a class filled with rowdy students that her colleague cannot discipline. We have to be strict about standards across the board. And it always comes back to the same thing for me: if the lesson isn't good enough for my kids, then it isn't good enough for anyone else's either.

But for all the awkward conversations I have had with colleagues, there has been so much more to celebrate: teachers who early on in their careers needed that extra support, then went on to be inspirational heads of year in other schools. One colleague in particular stands out in my memory, a maths teacher just so passionate about her subject that, when she got excited, she spoke so quickly the students didn't understand a word she was saying. I very gently alerted her to the fact – just as the Ofsted inspector had once advised me – and she asked how she could improve her communication skills. I gave her tips on how to deliberately slow down the way she

spoke when she was explaining, how to check, and check again with students, to make sure they were taking in all that she was saying, getting them to repeat it back to her so she was sure they understood. It worked. Later, she was promoted to one of the middle leaders of the school, and I couldn't have been more proud.

Eleven

The job of the teacher is always about the students, and so we are perhaps guilty ourselves of overlooking our colleagues. We can be so focused on the kids, and all the responsibilities that come with that on a day-to-day basis, that we forget to celebrate one another's achievements. I was surprised then, when an ex-colleague of mine contacted me in 2017 to say he had nominated me for the Global Teacher Prize. I had never even heard of it, and didn't take the time to look it up when he mentioned it, so convinced was I that nothing would come of it. Weeks went by before he contacted me again, asking if I'd heard from them.

'Nothing,' I replied.

I had a more pressing task in front of me. Finally, after fifteen years, John and I were getting married. I had organised everything, right down to designing the place names and flying in family from Greece, yet it was the day before my wedding that an email arrived in my inbox, warning me I had until midnight to respond to the

nomination. It turned out that all their previous attempts to contact me had gone into my spam folder.

The night before my wedding I sat with a needle and thread taking John's trousers up with one hand and replying to the email about the prize. It turned out they were looking for two criteria in particular – a teacher who excelled in their practice, and someone who supported and celebrated their teaching colleagues. The questions were pretty generic, which was fortunate as I only had minutes to answer them: *Please give examples of how your teaching has produced excellent results in terms of student outcomes. Discuss your approach in driving innovative and effective instructional practices for your students inside and outside the classroom. Share how you are contributing to the improvement of the teaching profession.* Among others.

I quickly wrote two paragraphs for each question, but then one in particular caught my eye: *If you were to win the prize, how do you plan to spend the money in the short term and over the next ten years?*

I looked up the details of the prize. The winner would receive $1 million – I'd had no idea.

But the answer to that question was easy.

Over the course of my career I have witnessed how the budget has tightened every year in schools. This is backed up by the numbers – School Cuts, a coalition of six unions, conducted an analysis in 2019 that revealed that 80 per cent of schools will have less funding per pupil in real terms in 2020 than they did in 2015. These squeezes on

the budget have primarily affected the arts. A 2018 BBC survey showed that nine out of ten secondary schools had cut back on lesson time, staff or facilities in at least one creative arts subject, as they are forced to prioritise the EBacc. Research from the Education Policy Institute has shown a decline in the proportion of pupils taking at least one arts subject at GCSE level. In 2016, it reached 53.5 per cent, the lowest level for a decade. Yet the creative arts are part of the fastest-growing sector of the British economy, contributing more than £100 billion in 2017. But where will our creatives of the future come from if they do not hone their craft at school? Research has also found that 87 per cent of jobs in the creative economy are at no or low risk of automation, compared to 40 per cent of other jobs.* So why are we not preparing our children better for the workplace, rather than training them up for jobs that may be taken from them by a robot?

As I had moved up the school, I had sat in those very meetings where the senior leadership team had been asked to make tough decisions. Every year it was the same: this is how much we have; this is how much we need – what can we get rid of?

Schools are always struggling, and for this reason the arts are often seen as surplus to necessity. When schools

*Hasan Bakhshi et al, *Creativity vs Robots: The creative economy and the future of employment*, Nesta, 2015.

are judged – and ultimately funded – on the exam results of core subjects such as English, maths and science, when it comes to where to allocate cash, these subjects will always take priority. Although there has been a recent shift in the focus for the school curriculum to be broad and balanced, this is still contradicted by the expectations placed on schools by Ofsted that the majority of their cohorts should still be undertaking the Ebacc. But I have sat in those same meetings when we have had to make decisions about whether school trips – the very days of school life that people remember long into adulthood – are really necessary because they don't add anything to their curriculum-based learning. The well-being of children is sacrificed for academic progression. And it is the students who live in deprived areas who suffer the most.

I know from my friends who send their own children to private schools how they spend hundreds, if not thousands, of pounds each year on extracurricular activities. These are the opportunities that middle-class children have easier access to: violin lessons, drum lessons, after-school drawing clubs, dance, hockey, racket club, karate – the list is endless. But why shouldn't all children have these experiences? Why can't they all have the opportunity to overhear visitors to an art gallery discussing a great painting? Or stand in the Globe theatre and watch a Shakespeare play? As a school we used to be able to subsidise music lessons for students, but now we're not able to do that due to budget restrictions, and many

parents cannot afford to pay for their children to learn an instrument. How many great pianists or composers of the future might there be in a school like Alperton who will not get the chance to discover their hidden talents? There is a huge discrepancy between the haves and the have-nots. I have witnessed it first hand, both sitting in meetings and interacting with students, and it is playing out in the workplace. A 2018 study released by Create London and Arts Emergency found that the percentage of people with working-class origins working in publishing was just 12.6 per cent. In film, TV and radio it was 12.4 per cent, and in music, performing arts and visual arts, it was 18.2 per cent. The arts is an industry dominated by the middle classes because their children can afford access to it.

But more often I have witnessed the positive impact of giving kids access to the arts. I have seen – as documented in the pages of this book – children who have been unlocked from silence or trauma thanks to the power of putting paint on canvas. I have met great artists from the most disadvantaged backgrounds who have gone on to study the arts at university because free school clubs gave them the opportunity to learn their craft. I have seen SEND children express themselves in a picture in a way they can't with words. I have seen how their self-esteem has grown, how they can find in the art room a sense of belonging, how a talented Year 7 student can sit alongside a Year 11 student and the two of them can communicate

on a different level because they are both good at art. I see that camaraderie between them. I see confidence and communication skills grow. I see children putting themselves forward in other school departments. I see happier kids. In a big school like ours, every child is a ghost until they find their home – the one thing they really love – and that's when they connect themselves with other kids.

Some of these children have never used acrylics, or done screen-printing, or made mosaics, or learned etching or photography – a lot of them don't even have a pen and paper at home. But I've seen students flourish in the art workshops that I have run. And for this reason, my dream had always been to offer more workshops to children from these backgrounds, to equip them with more skills in the arts, to allow them more time to perfect a piece of work – to open an art hub not just for my students, but all students across my borough. That is what I wrote, and sent it off.

Then I put it out of my mind to get married.

It was nearly two months later that I received another email from the Varkey Foundation to tell me that I had reached the longlist of fifty teachers, and that was the first time that I had a proper look at the website. I couldn't believe what I found there. This prize had received more than 35,000 applications that year, from 137 different countries. The foundation stated that they believed in

quality education for all. I read: *Through our work across the world, we've seen how great teachers can transform the lives of their students and their wider communities for the better...We believe that teachers are critical to our global future.*

The Global Teacher Prize is presented annually to an exceptional teacher who has made an outstanding contribution to their profession. I clicked on some of the previous winners: a teacher of isolated Inuit communities who fostered some of her own students; a Palestinian teacher who helps children exposed to violence. I was certain, after reading about these incredible teachers, that I didn't stand a chance of winning. An art teacher from a London academy school? I don't think so. Even to be longlisted out of all those teachers was a great honour in itself.

That week was so exciting at school. My head teacher, Gerard McKenna, mentioned me in the school briefing, and a local Brent magazine came to the school to do an interview with me. The day it was printed my mum went to the library and took away every single copy that she could find so she could hand it out to people at church.

I still didn't dream that I would make the shortlist, but Mum kept saying: '*Anodera*, Andria.' Translation: And more things to come.

Two months later, in February 2018, the Varkey Foundation contacted me to arrange a Skype call for that Friday at 4 p.m. The Year 8 parents' evening was starting at 4.30 p.m. and so their timing was perfect, but not

having used Skype before, I set up my phone in my school office, and got various friends to trial my Skype link at 3.30 p.m. and 3.45 p.m., just so I could make sure it was working. The call came at 4 p.m. on the dot. It was an informal chat with the foundation's chairman, and I told him how happy I was to have made it to the last fifty.

'We're announcing the top ten next week,' he said.

'Wow, good luck with that,' I said.

'And we'd like you to be in it.'

It was at that point that I screamed. I dropped my phone and when I picked it up again, everyone on the call was upside down.

'Shit, shit, oh my God,' I said, as I struggled to get them the right way up again.

I was asked to keep the news to myself until the official announcement four days later, and was told the winner would be announced at a prize ceremony in Dubai the following month. I had to go to the parents' evening, unable to disguise the smile on my face. Students who had been on my red list earlier that day suddenly got glowing reports.

When the official announcement was made, I was sitting in a Manchester hotel room, waiting to go on BBC Breakfast the following morning. I stayed awake until midnight, when the embargo was lifted and the stories of my fellow finalists were revealed on the prize's website. Their stories were incredible: a Colombian teacher who had reduced teenage pregnancies to zero; a South

African activist who worked with a hundred schools to improve literacy; an Australian head teacher who created his own YouTube channel to teach every child maths; a Belgian teacher who organised 250 schools in sixty-six countries to get involved in climate-research projects. I read every single one of their stories with tears caught in my throat. I didn't compare myself to them – they were all so different, how could I? Instead, I was excited at the prospect of meeting them at the award ceremony in Dubai. Yet when I finally slept, I drifted off with the same question spinning inside my head – why me?

Life changed for ever the following morning. I was inundated with requests for interviews, not just in the UK, but from all over the world – even the Greek and Cypriot TV stations came to film at the school. When I told Mum that I was going to Dubai for the prize ceremony, she told John that she and Dad were accompanying me.

'You're staying here and looking after the kids,' she told him.

Luckily he's used to being bullied by his Greek mother-in-law.

I think that it was the multicultural element of my story that captured the attention of the international press. Many schools have never dealt with such a wide spread of different cultures, but lots of countries were now having to deal with an influx of migrants, and I was being hailed

as the poster girl who had made it work. For me, that was my daily life, but interviewers found it incredible that I had taken the time to learn a few words in so many languages so that I could greet parents and pupils, that I had worked with families to understand how they lived, that I didn't believe that all these different cultures had to adapt themselves to us, but that we could learn so much from them. Aside from that, I was also championing the arts, a subject that rarely gets recognition, yet we all enjoy it as part of our everyday lives.

My mum made a scrapbook, collecting every single interview that I did and pasting it inside. In Greece somebody even named a road after me and sent a photograph of it that went straight into Mum's book. The students at school loved seeing me on television: I became a celebrity overnight to them.

My head teacher couldn't have been more supportive. It wasn't unusual for him to call me at home in the evening to check how the interviews had gone that day, or to give me advice when it came to speaking to journalists or politicians. I couldn't have asked for a better mentor at that time. He was always checking in to see what support I needed, and the rest of the staff rallied round to cover my lessons and other school commitments. However wonderful the shortlisting was for me, I also knew it was a massive disruption for everybody, including the students, and I only hoped it wouldn't have an impact on their results. Eventually the school paid for a freelance

senior teacher to come in and support me in doing my role, which was a huge financial commitment for them.

For two weeks the press interest was unrelenting, and just when it started to die down, it was time to travel to Dubai for the prize-giving itself. Only it wasn't just an award ceremony. The Global Education & Skills Forum was taking place there at the same time, a huge global conference attended by every minister for schools from countries throughout the world, as well as other leaders in education and, most importantly, teachers. I thought back to that middle-class school where I had done my teacher training, and how I had decided all those years ago that I would stay within my comfort zone at a school like Alperton. Over the next few days I was due to give talks and appear on panels, but I didn't know what these people wanted to hear from me. These were all experts in their field – what could I possibly teach them?

At the first panel I appeared alongside the artist Michael Craig-Martin.

'Oh my God, I teach you to my students,' I said, throwing my hands up to my face.

I had been asked to take along a piece of art that had inspired me and to tell the story of why. And it was in that room, with more than a hundred people listening, that I told the story of what Picasso's *Weeping Woman* meant to me.

For a moment I was transported all the way back to Miss Calder's classroom, with her pots of red geraniums

perched on the windowsill. On the wall was a poster, tattered and curling at the edges, and secured to the paintwork with pieces of old Blu Tack.

'I didn't like this painting,' I told the audience, as it appeared on the projection behind me. 'As a child, it used to terrify me; her green face reminded me of the wicked witch in *The Wizard of Oz*. I didn't know why my teacher had put it up in our classroom. But when I got into secondary school, I was given some homework where I had to look at a piece of artwork and write about it, and I decided to choose *Weeping Woman*. What I realised then was just how powerful this piece is, that Picasso was trying to capture movement in this woman's tears, that he was trying to paint emotion – something we struggle to capture with words – onto the page with just a brush. I learned to love that painting. I now teach children about cubism, and I know that it is my job to bring these pieces to life for my students, to give them meaning, to help them to connect to them.'

I paused, looking around, hoping the audience was still following me. And then I started to tell them the story of Alex. A boy so severely dyslexic and disruptive, a boy who by the age of twelve could neither read or write, a boy whom every teacher dreaded teaching.

'And yet, when I taught him about cubism, when I showed him Picasso's *Weeping Woman*, something connected.'

The next painting that appeared on the projection was Alex's cubist drawing from my class. I heard a collective

gasp in the audience before I even told them that Alex had painted it, and that the recognition he received in that class had changed his school life.

'That is the power of art,' I said, and as I sat down in my seat the audience rose in applause. I looked around, embarrassed, uncertain for a second whether their applause was for me – or perhaps it was for Alex, the real star of the show. But at least I knew now what they wanted to hear. They wanted to know about the students; they wanted to hear the real stories that teachers like me deal with on a constant basis.

The following day I had to give a lesson. That was the most comfortable I felt throughout the entire time in Dubai. Terrified the materials I'd requested wouldn't be there, I brought my own in my suitcase – floristry tape, wire and balloons – it reminded me again of my first days in teacher-training placements, and the bag of pencils, rubbers and rulers I carried around with me.

Professionals of all different nationalities attended the lesson – including the Egyptian minister for education – and without a common language between us, I taught everybody how to make flowers from the material I'd supplied. You never quite get used to seeing the same delighted looks on the faces of adults when they have made something, as you see with children. Nothing beats creating something with your own two hands, whatever your age.

I met all my fellow shortlisted nominees at a dinner a couple of nights before the prize ceremony. I bonded

instantly with them – we were, after all, the only people in attendance at the conference who understood how it felt to be in the top ten. Each of their stories was amazing; I felt so honoured to be included among them. Together we went along to talks and appeared on panels alongside one another. By the night of the prize-giving itself I would have been delighted for any one of them to be crowned the winner.

I loved getting my hair and make-up done – I wasn't used to such pampering. I wore a dress that I'd bought from Brent Cross Shopping Centre and knew that somewhere, in that vast audience, Mum and Dad were sitting. From the front row we watched clips of every one of the finalists' ten-minute videos. The sight of the Alperton students so many miles away from me brought tears to my eyes. And then, finally, we were asked to step up onto the stage for the winner to be announced. The ceremony was lavish and elaborate. We watched a screen as Lewis Hamilton drove the prized trophy through the streets and right into the conference studio itself. South African comedian Trevor Noah took to the stage to announce the winner. But from where we were sitting, it was difficult to hear him, and so, for a few seconds after he announced my name to the crowd, I had no idea that I had won.

It was one of my fellow finalists, Eddie, who turned to me and gave me a massive hug: 'It's you, Andria,' he said, 'you're the winner.'

It took a moment for what he was saying to sink in. As the reality dawned, I hugged every one of the finalists as if they were a safety net I wasn't yet ready to leave.

The audience were going wild, the cheers and claps drowning out any nerves I felt as I walked towards the podium. I just tried to breathe, reminding myself to enjoy the moment. I was determined not to cry; I wanted my speech to be powerful, strong, solid. I took the trophy, and then stepped up to the lectern, looking out at the sea of people before me.

'Just imagine you're taking an assembly,' I thought to myself as I started to speak, knowing there were 4,000 people in the audience before me.

I took a deep breath: 'I want to share this honour with my fellow teachers and wonderful students at Alperton Community School in Brent, London...' I paused, as if I couldn't quite believe it myself. 'London!'

A cheer rose from the audience.

'I also want to share this honour with my fellow finalists – incredible people – and all the teachers from all over the world, because tonight it's not about one person, it's about celebrating all teachers and recognising the important role they play in shaping the future for our children.'

I thanked my mum and dad – searching the audience for them – my husband, my daughters, my head teacher, Gerard, who was also there, and my friends.

'The community where I teach in Brent is beautifully diverse, and indeed is one of the most multicultural communities in the world. Nearly half of our residents were born outside the UK and over a hundred different languages are spoken by our students in our schools.

'For many of our students, English is not the main language spoken at home. It's also a community where many of our students unfortunately live in challenging circumstances. They have tough lives. They live in crowded homes and sometimes it's a challenge for them to find peace and a quiet place to study. Others are unable to stay for after-school activities because they are carers or have to look after their younger brothers and sisters while their parents go to work.

'What is amazing is that whatever issues they're having at home – whatever is missing from their life or causing them pain – our school is theirs. And I know that if our school could open at six o'clock in the morning, there would be a queue of children waiting outside at five o'clock in the morning – that's how phenomenal they are. So the most important thing we can do as teachers is to ensure our schools are safe havens.'

The audience were silent. I continued: 'We also have students who have stable home lives and they choose to come to our school. This is because our school celebrates diversity and shapes them into real citizens who accept and appreciate one another.

'So, to all the students all over the world, I say whatever your circumstances, whatever your troubles, please know that you have the potential to succeed in whatever your dreams may be and that is a right that no one should take from you.'

The audience applauded.

'Since I was young, my dream was to be an art and textiles teacher. I am proud to be an art and textiles teacher. The arts have to fight for space in the curriculum and for funding; they are often the first budgets to be cut, and this is so wrong.' I paused. 'You can clap now.'

The audience laughed.

'The arts teach students how to think creatively, which will be important for the jobs they are likely to do when they leave school. They also teach resilience and that perseverance can pay off. For my students, the arts provide a sanctuary, a place where they can safely express themselves and connect with their identity. We know that students who spend more time on the arts can become more successful at the rest of their studies too. My students are evidence of this – they thrive – look at our results for a curriculum that embraces the arts.

'I've just spent the most amazing few days meeting with other phenomenal teachers from around the world.'

I turned to my fellow finalists and held up my trophy.

'I'm celebrating this win with you and all our teachers at home – this is for all of us.'

Twelve

The days after winning the Global Teacher Prize were nothing short of a whirlwind. I could never truly capture it in these pages. There were glamorous moments: parties, celebrity interviews, posh dinners. After my parents returned to the UK, there were endless rounds of interviews with press from all over the world. There were TV appearances. There were incredible moments meeting educational pioneers that I had admired for years. But the moment that sticks in my mind after everything is what awaited me back at Heathrow Airport. I had been told that I would be whisked straight from my red-eye flight to meet the prime minister at Downing Street, and so I had done as suggested and packed a change of clothes in my hand luggage, doing a quick change in the airport loos when we landed. Only when I came through customs and into arrivals, I could hear cheers, and saw crowds of people. I checked my watch: it was still only six o'clock in the morning. I was confused, wondering who they were there for. And then I spotted John, Sophia

and Anna Maria. I abandoned all my bags to run into their arms.

But there was more. The applause and cheers were coming from a huge crowd of people that had gathered in arrivals, made up of Mum, Dad, my brother and sister, my nieces, my friends, my head teacher, my teaching colleagues, local councillors, our MP Barry Gardiner, and around one hundred of my students, all waving artwork at me.

'Miss! Miss! You did it!' they cheered.

I threw my hands to my face and burst into tears. I could not believe all of those people were there just for me.

'We're so proud of you, miss!' they said, many of the students close to tears themselves.

Gerard told me that the school had opened especially on the award night to stream the ceremony live. He said teachers told him the whole hall had erupted in cheers and applause when I was crowned winner.

'They wouldn't miss welcoming you home,' one of my colleagues said.

From the crowd my mum appeared, wearing a T-shirt she'd had printed with my face on it. In her hands was a wreath made of olive leaves, and as she reached up, she placed it on my head. I felt so happy to have returned to my roots – to solid UK turf, and all these people who I loved so much.

All I wanted to do was stay with them and celebrate, but I could feel people from the Varkey Foundation gently

tugging at my sleeve, reminding me that the prime minister was waiting, and so I said goodbye, giving as many people as I could a high five, and headed to Westminster.

The conversation at Downing Street – which I outlined in the first few pages of this book – had lit a fire inside me. Over the next couple of days I went over and over it in my head, indignant that after so many years of seeing how the government had been letting down schools, reducing budgets, stripping the arts of vital spending, they now wanted me to help them with a recruitment drive for teachers. But as aggrieved as I was by their offer, I was anxious too, worried that I had said too much, that maybe the Varkey Foundation had wished that I could have politely accepted their offer, that I could have been the poster girl that the prime minister and her schools minister wanted me to be. But I couldn't. In that moment, for this arts teacher from Brent, I realised it came down to a matter of integrity. It took a phone call from Vikas to put my mind at ease.

'Vikas,' I started, 'I just want to apologise—'

'For what?' he said.

I told him what I'd been worried about, that I should have just accepted the offer made by Nick Gibb, that I shouldn't have said all those things I did about how let down I was by the government.

'Don't be ridiculous,' Vikas said. 'You were brilliant.'

He wasn't calling to dissect what had happened at Downing Street. He had something more important to

discuss. When we had met for dinner in Dubai the night after my win, he had asked me what my plans were for the prize money. I told him the rough idea that had been forming in my mind for years, my dream of an arts hub for inner-city schools, somewhere that children could meet and learn from real artists.

'Let's talk about how we're going to make it happen,' he said.

A week later I met him again at the Varkey Foundation's London headquarters. He introduced me to members of his team, people who he said would help me to brain-storm exactly what I wanted to set up, people who could help me make this dream a reality.

'I just don't know where to start,' I said.

'We can help,' Vikas said. 'What is the one thing you think makes a huge difference to you and your students in the school?'

I thought for a moment.

'When I was younger, my art teacher would organise for friends of hers who worked as artists to come into school and tell us about their work. I found that so inspiring; it gave me the confidence and the belief that I could get a job in the arts world. It made me want to achieve more, to be more competitive. It gave me a pathway that I could focus on, and I see the same from my own students when we bring in friends or artists and they show the students their work – you see their faces lighting up. They get to ask

them the questions that matter to them: What's it like? Who are your customers? How much do you get paid?'

Everyone around the table laughed.

'I want to build something like that, a not-for-profit charity that is free for schools that brings these people into classrooms and shows students that they are just as capable of being an artist too one day... they would be like artists-in-residence.'

'That's a great name,' Vikas said. 'AiR.'

Our meetings took place over a matter of weeks and months, carefully and concisely getting together a plan, formulating budgets, personnel, the charity's mission statement. In between, my life was filled with print and broadcast interview requests from all over the world. Not only that, but I started receiving requests to do inspirational talks, not just in the UK, but in places as far flung as Chile, Argentina, South Africa and America, as well as all over Europe.

It wasn't just the educational world, but the arts world too. Suddenly I was somebody who was championing them, someone speaking out for the lack of investment both financially and culturally. I was invited to some incredible events like the Royal Academy of Arts' Summer Exhibition or to meet the head of the Serpentine Gallery, who put me directly in touch with artists and key art-world ambassadors, who pledged their help when I told them about the charity. I was invited by the World

Economic Forum to attend their conference in Davos as a cultural leader.

At school, my mail bag was bursting and it was difficult to respond to every request or letter of congratulations. But one afternoon, as I sat in my office, I noticed among the pile on my desk two unopened, handwritten envelopes. One was very posh – my name and address written in fine calligraphy on thick, watermarked paper. The other was a small blue envelope, the handwriting in spidery black biro. I opened that one first.

You may not remember me, it started, but I taught you when you were nine years old. I am a good friend of Miss Calder, who has moved back to New Zealand now, but I wanted to write and tell you how proud we all are of you.

The letter was signed from Miss Enoch. Of course I remembered her. She was the teacher who told me I had done a kind thing when I picked Ibrahim first for my rounders team. How could I forget? I was so touched that a teacher I hadn't seen in over thirty years had taken the time to write. This is the power of the student–teacher relationship.

I opened the second letter carefully, gasping when an invitation to attend the V&A's Museum of the Year Awards fell out – and better still, they wanted me to be a guest speaker.

But as wonderful as all these requests and invitations were, I was still trying to teach classes, trying to fill my obligations as part of the senior leadership team at the

school. It was becoming untenable. I went to speak with Gerard, who had always been so supportive. Not only did he agree I could work part-time, but he said I could rent a building on the school premises to get the charity up and running.

I was so overwhelmed with interview requests that the school hired someone to deal with social media who then took responsibility for organising my diary. I realised how disruptive it was for the school and the students, but there were so many highlights too. Her Royal Highness the Duchess of Cambridge visited the school after my win and spent time looking through some sixth-form students' artwork. She studied art history at university and so she had a great appreciation for everything that they were doing. She also has a great interest in mental health, and I was able to tell her just how much studying the arts improved the students' well-being, how it could unlock someone from trauma, or get a mute child to speak.

As she left, I pressed into her hands some textile work. It was something very simple, just stitching on calico, but it was something I had treasured for years, beautiful and colourful and inspired by Van Gogh's Starry Night. I hung on to it just a second longer than I should have done as I told the duchess the story of how it had been done by one of our students who struggled so much with mental illness.

'I understand what this must mean to you,' she said.

'But we got her through it,' I assured her as she left.

The charity, Artists in Residence, was launched in June 2018. Over the previous few months I had attended many dinners and been introduced to some brilliant and powerful people like Lord Melvyn Bragg, artist Mark Wallinger and historian Simon Schama. They were all there to celebrate the launch of the charity.

I had learned so much in piecing it together, although it very much felt like learning on the job, as if I was both building a plane and flying it at the same time. It definitely wasn't as easy as I thought it would be – but I had that energy, and along with the support of the Varkey Foundation, I felt I could achieve anything.

I employed the social media manager that the school had taken on for me to help me with the day-to-day running of the charity, and I set up a board of trustees, as well as learning all about the admin, and sourcing new donations, and recruiting artists who would be willing to work with schools. My plan was more defined now, putting artists, musicians, writers and other creatives into schools that needed them. They would be working with the very classes that the schools had identified as struggling, the whole aim being to reinvigorate the school life of these children by inspiring them and helping them to create work they could feel proud of. My aim was to start small, although for me that included not only the inner-city London schools, but those in Greater London too. The focus for the first year would be on getting artists into those schools before expanding out to the rest of the

country. We had one criterion for schools: that at least 20 per cent of their students must qualify for free school meals. That way we could be assured that the school was in a deprived area, that it was these students who needed our help the most. The mission was always to raise the profile of arts in education.

After the launch I was inundated with donations and offers of help; the famous theatre director Michael Attenborough signed up to be one of our artists-in-residence, as did Alexander Newley, Joan Collins's son and a brilliant artist in his own right.

But then I had an offer of support from a rather unusual source. Matt Hancock at that time was the secretary of state for the Department for Digital, Culture, Media and Sport. I was contacted by his office saying that they were looking to do something similar to my charity and had ring-fenced some money: the department wanted to use the funds they had to match the prize money I had received – another £700,000. I could barely believe what they were saying. This offer came with a whole history of my experience as a teacher attached to it. Better than the finances was the recognition, the realisation from the government that arts in education mattered. It seemed to me that it had taken my win all those miles away in Dubai to convince them that British children deserved opportunities in the arts, that they needed to invest in children's arts education to produce the artists, the architects, the writers, the dancers, the actors and the fashion designers

of the future. My message had finally got through. I got back in touch with them immediately, thanking them for their offer, saying that I would be willing to do anything to help make it happen.

And then I heard nothing. Theresa May had a reshuffle in her Cabinet and Matt Hancock was moved; with him, it seemed, went my opportunity. Weeks, then months went by and there were no further developments, no other correspondence. It was as if the offer had never been made.

It was hard to disguise the disappointment, but I had enough to do in the meantime. We rolled into a new school year – our first, officially, as a charity – and we started to receive interest from London schools for some of our projects. They came to us with all sorts of problems: low attendance or school refusers; SEND students who weren't making progress; for another school the focus was EAL students.

I was busy matching these schools up to artists, and auditioning artists myself – we had been overwhelmed by responses, but not all artists had experience of working with students or knew how to speak their language.

Six months later, a lifeline: an email arrived from the Department for Education (DfE). They were picking up on the conversations that had been started by the Department for Digital, Culture, Media and Sport. The funds had been passed over to them to allocate and they wanted to go ahead after all. I was absolutely thrilled. By

then it had been almost a year since my win, and my life was far from what it once was. There were months when I was doing three or four international talks, so it felt like I spent more time in airports than in the classroom. But I used this time to work on the implementation plan that the DfE said they wanted from me to go ahead with the funding. They needed facts, figures, a complete business projection for the charity. We had started out small, helping schools in London, but quite understandably they wanted to know our modelling for expanding out to the rest of the UK. I wasn't quite ready to make that leap, but if it meant they would match my funding, I decided to throw everything into it. It represented weeks of work – weeks that I could have spent applying for other grants – but I was sure that this one would be worth it, that the government was ready to invest in arts in education and that could change everything.

Two months later I submitted everything that they had asked for, convinced that it was a strong plan, that our modelling was accurate, that with the government's support we could finally turn around the way schools are forced to view arts as surplus to the expectations of the curriculum. It felt as if, through me, every arts teacher – every drama, or design and technology, or dance teacher – had been heard.

So we waited, and a few weeks later, an official from the DfE came to the school to discuss the project with me. I was so excited for that meeting, to put into place

a dream that would change the life of students all over the UK.

We sat down in my office. He cleared his throat.

'Andria, I'm afraid that the department will not be able to offer any funding for your charity,' he started.

I stared at him in disbelief. But they had come to me with this offer.

'The advice from our lawyers is that if we are going to invest in a project like this, then it must go out to tender with other arts organisations. However, if you would like to help us come up with a competition, then...'

How naive I had been to assume that the department would support us, that they had recognised the importance of what Artists in Residence was doing. They had been the ones to approach me, this had taken weeks of work, and only now had they spoken to their lawyers and decided they couldn't do it at all.

In some ways this epitomised my career as an arts teacher. We had never been able to rely on the government to help us. Nothing had changed.

The official left, and it took a while to pick myself up again. But once that fire was lit again inside me, that determination that I would deliver arts to the students – with or without government help – I knew there would be no stopping me. I got over the disappointment and my full focus returned to the charity, especially when we started putting artists into schools and I saw the benefit of everything they were doing with pupils.

Michael Attenborough has worked with some of the most amazing theatres in the world; among other roles, he has been artistic director at the Almeida Theatre and the Hampstead Theatre, associate director at the Young Vic and the West Yorkshire Playhouse and for years he was resident director and executive producer at the Royal Shakespeare Company. He is also from the famous Attenborough family – in terms of credentials you could not get any higher. And yet in 2019 he went to work with a group of GCSE students at an east London secondary school.

Drama teachers at the school contacted Artists in Residence because they desperately wanted to make improvements in their subject. They had two classes of GCSE drama students, but they were finding it hard to engage with Shakespeare, which was reflecting in their results. The subject, as per our benchmark, was on the school's School Development Plan as one of its improvement priorities.

The school fitted our criteria: it was situated in Hornsey, an area with a high take-up of free school meals and of mixed ethnicity. In some ways, it was no wonder that Romeo and Juliet were not speaking to these students – the play must have felt so outdated and removed from their lives. But if anyone could bring Shakespeare to life for them, it was Michael Attenborough.

Michael visited the school three times, and both the students and the teachers loved him. The first session he did with the students was to walk them through *Romeo*

and Juliet in its entirety over two hours. As he spoke to the pupils, he showed slides projected behind him, famous scenes from theatre productions of *Romeo and Juliet* that he had directed, pictures that could start to bring the characters to life for the students. The students were captivated by him within minutes, in awe that a man who had directed productions – who had been responsible for every little detail in the pictures they saw projected onto their classroom walls – had taken the time to come to their school and talk to them.

He paused on certain slides, getting the students to take in every aspect.

'Why is she holding her hand like that? What does this mean?' Michael asked them. 'Why is she looking up at the sky? What is she thinking?'

Arms flew up in the air. Students who had once sat behind desks, taking it in turns to read words that they could barely get their tongues around, were now desperate to offer their own suggestions as to the meanings behind the story, the thoughts and feelings of the characters, themes and ideas that they could identify with.

The second session he did with the GCSE students was to get them to do the acting, to imagine themselves as real actors and actresses, to direct them in the same way that he had so many famous names.

'Is your tone right?' he said, stopping one of the scenes. 'Think about what you're feeling in this scene: reflect.'

The final session he did with the students was running through the production itself. By then they had left no sentence unprobed for meaning and feeling. The students connected with their subject in a way they had never done before. The performance was a great success. Emails from the English department followed, longing to know when Michael could come back to help their students too.

But what I found so incredible was that Michael had helped not only the students to see Shakespeare anew, but the teachers too. I had been so focused on what students could get out of the sessions that I hadn't quite realised the benefits it had for teachers as well.

In the early days, one of the sessions he did was with our own GCSE pupils at Alperton. I sat beside a very quiet Muslim girl, who looked at me from under her headscarf and whispered: 'Miss, that was the best lesson I've ever had. I really get Shakespeare now.'

I couldn't have asked for anything more.

In our first academic year of running the charity, we carried out twenty-nine projects at different London schools. All of them had particular reasons for asking Artists in Residence to work with them. Some schools were focusing on Afro-Caribbean boys who had achieved well in primary school, but for some reason, once they reached secondary school they were not making the same progress. For some schools, it was the attainment

of the white British students that was suffering once they arrived at secondary school. By analysing their own data, schools were able to identify where they needed to improve and it was in those areas that the charity wanted to help them through the arts.

Sculptor Alistair Lambert was asked to work with a group of school refusers from north London. For this particular group of fifteen boys in Years 9 and 10, the school had tried everything to get them – and keep them – in their lessons, but for some reason they were not inspired by the school environment. They wanted a session with an artist that would create something that the boys could be proud of, that would give them some ownership of the school each time they saw it, that would make them feel a part of the community.

Alistair isn't just an artist, but an activist for human rights and climate change, and he thought it was very important for the boys to decide what type of project they would like to work on. They had recently been learning about fish skeletons in their science class, and decided they wanted to make a replica sculpture. They got to work over a period of three days, salvaging bits of old furniture from skips and recycled pieces of plywood. Then, saw and drill in hand, they started piecing together their sculpture. For many of these boys it wasn't just what the work represented to them in school, as Alistair became a father figure to them as they worked together hands-on, but also that

the project gave them a reason to be in school, something to be motivated about. For so long they had felt that school held little for them.

When the sculpture was finished it was given pride of place in a corridor, where it still stands, the boys passing it every day and knowing that it was their contribution to the school. I was told by the head teacher just what a positive impact the project had on the boys, that their attendance had improved, that they were happier pupils as a result of the time they had spent with Alistair.

The projects aren't only about the students and the teachers, but they provide inspiration to the artists too – as well as a source of income. The artists get so much out of improving the way that students feel about themselves and their education, and that feeds into their own work. Most importantly – as I've always known, even from my own experience – by working with a real artist, children begin to think more widely about their own career choices. They see that working in the arts is an option open to them, that there are artists out there earning a living, and that this might, one day, be them. It is true, as I have said before, that you cannot be what you cannot see, which is another reason why I always make sure it is not just white men teaching the students in our projects.

Sarah Pimenta is an Asian textile artist, and she worked with a group of Year 5 students from a south-east London school who were anxious about taking the next step into Year 6 and preparing for secondary school. The head

teacher wanted them to feel nurtured on their journey, aware of the fact that their workload would increase, as would the expectations on them.

The school that Sarah went into is, like mine, a very multicultural one, and so it was incredible for the students to work with someone with a similar background to theirs to produce a beautiful banner celebrating the school's values, which would be hung in reception. Sarah really got the students to think about what the words in their school values meant to them. One of them was 'community', and so the children decided they wanted to base their screen-print on a tree, with its deep, strong roots absorbing all the nutrients while providing a home to animals and insects. They felt that the analogy of the tree really represented a school.

Around thirty pupils were hand-picked by their teachers as the ones who needed to work on their self-esteem or confidence, the kids who never got chosen for sports teams, the quiet ones who were often overlooked for their louder classmates. They were split into groups, and between them they created all the little animals and insects as well as the branches and leaves of the tree.

How proud those children must feel to arrive in school every day and be greeted by their own banner. The head teacher of that particular school told me that a mother approached him a few months later and said her daughter had been a happier child since the visit from Sarah.

Teachers are also inspired by seeing their subjects anew. I've seen lessons adapted afterwards, and tips and techniques that they saw the artists doing implemented in their own teaching.

Once I was showing an official from the Arts Council around our school when we visited a Year 9 textiles class. The year previously, artistic director Cinta Miller, who was more used to styling music videos than teaching in classrooms, had run a workshop at our school with Year 10 students recycling clothes and showing how things could be adapted and redesigned. A year later when I walked into the Year 9 classroom, the teacher was doing the same project.

'I just felt so inspired by what Cinta did that I thought I'd do the same project with the Year Nines,' she explained.

Her timing couldn't have been more perfect, as the Arts Council official was responsible for funding – luckily I managed to persuade him that this was not staged. But I was just so delighted to see that this teacher had adapted her curriculum around the work that she herself had learned from a real creative working in their field. My whole vision for the charity had been a holistic one: that teachers could take those ideas and embed them in the curriculum, and this was happening naturally.

When I first started at Alperton Community School we had four art teachers and two groups of GCSE art students. Today the teaching staff has expanded to seven,

and as well as three groups of GCSE art students, we have two groups of GCSE textiles students, as well as A-level classes. Although this is only anecdotal evidence, my school alone is proof that if you offer students a subject, if you inspire them by giving them the tools to learn and teach them in an original and captivating way, they will not only come to your subject, but they will excel in it.

Almost a year after launching the charity, I felt I couldn't have asked for much more – both the kids and the artists were thriving, but there was one more surprise in store for me. In April 2019 John and the girls, and Mum and Dad, joined me for a very special ceremony at Buckingham Palace. I had been given an MBE (Member of the Order of the British Empire) in the New Year's Honours list, and Prince William was conducting the investiture. We checked ourselves in the hall mirror before we left our house, all of us dressed up in our finery. I could hardly believe that we were leaving our Brent street for Buckingham Palace.

As Prince William attached the medal to my lapel, we talked about my work at Alperton, the students, the arts, the highs and the lows. And he told me how much his wife had enjoyed her visit to us a few months before.

'We have the piece of textile work that you gave to her hanging on our wall at home,' he said.

I'm not sure what made me feel more proud: the fact that I was standing in Buckingham Palace myself, or the fact that a piece of art that had been created by one of

my students was hanging in a royal home. I thought of all the struggles that particular student had lived with – her only respite being her time spent in the art room with a needle and thread.

It was the ultimate reminder that anything is possible.

Epilogue

Dear reader,

Thank you for spending your time with some of the pupils, past and present, from Alperton Community School. I hope you have found their stories as inspiring as I have over the years. I hope you can see all the work we have done, the wins we have made, and our frustrations at the parts of the system that we have not been able to change. More than that, I hope you see how much work there is still to do. And we need your help to achieve that.

Humans the world over have a great appreciation of art and culture. For every one of us it is a part of our daily lives, feeding into everything we do: the graphic designers who come up with the ideas for our cereal packets; the creative directors who commission catchy adverts; the screenwriters who create the storylines for our favourite shows; the musicians who write the songs that get stuck inside our heads. Even if you don't go to museums and art galleries, the creative arts are central

to our existence. It's what makes us all human. But it is clear that there is not that same appreciation for arts in education.

Since my win, I have been inundated with requests to do inspirational talks all over the world, for teaching organisations and ministries of education, and to corporations who want their staff to be more creative. Just like in Dubai, at first I wasn't sure what they wanted me to talk about. Some of these people were leaders in their field – what knowledge could an art teacher from Brent possibly impart? But the talks represented a chance for me to learn about education from so many different perspectives – to attend educational conferences, to understand the latest developments in teaching practices, to know what the business world expected from our students after they left school – and to feed all this back to my students and share it with my colleagues.

As I have done in these pages, I impressed on my audiences the stories of the students. It was only through their lives and experiences that I could tell the tales that so desperately needed to be told – that the arts in education are as vital as the air that we breathe. Because to raise the creative people of the future, we must invest in them.

At Harvard University I told new graduate teachers about Alex and his cubist painting. I told them about Alvaro and how the power of art helped him to speak again. I talked about Fatima, and how her escape from

Syria had been captured in the wild and wonderful paintings she did in my classroom.

Today I tell these stories everywhere I go, whether it is to teachers like me, head teachers, CEOs or world leaders. People all over the world are always inspired by those kids whose stories began in my classroom. I can see how connected they feel as I speak. I look out onto the audience and see a sea of faces nodding back at me as I talk about my own frustrations.

The more talks I have given, the more I have understood the individual worries and concerns of every country. It seems to me that Scandinavians are doing more than most to support the arts in school. That Spain – where teachers more often fund their own professional development – is most likely to call on me to talk about how to teach in a multicultural classroom because of how their migrant population has exploded. That girls in Chile are still fighting for equality in education and their rights to attend the same lectures as their male peers. It doesn't matter where in the world you are reading this book, there is still more work to be done.

There are countries that we could learn from, like Switzerland, where schools close down every Wednesday afternoon for people to spend time with their families – even the teachers. I like this idea. It is as if the Swiss government is telling teachers: 'Your own kids are as important as the ones you teach.' But I also hear from teachers who have it a lot harder – like those in Mexico,

who navigate drug cartels every single day. Stories like that put our tales of long hours and poor pay in perspective.

Everywhere I go, I emphasise the importance of the school community, that although these people – teachers, head teachers, corporate managers – are hearing them from me, these stories, these experiences are the collective tales of being a teacher in the twenty-first century. And none of what I've achieved would have been possible without the support of my colleagues from Alperton Community School – my fellow teachers.

There are probably millions – billions – of people out there who have a story of thanks they would share with their teacher if they could. There is not one person who cannot say that a teacher inspired them to be better, however they did it. I have been one of the lucky ones whose day job has propelled me into a position where I heard those thanks from people.

There is only one Global Teacher Prize, but there are millions of stories out there of teachers who have made a difference, who need to be celebrated, and I would love to hear their stories, as you have heard mine. Just because the government does not seem to value the day-to-day work of the people raising the next generation, it does not mean we – the people – don't. We need to speak up about education and how it matters to us, the difference it made to our lives, and what it may do for our children, our nieces, our nephews, our grandchildren and our friends.

As teachers we must always be aware of that huge responsibility we have, of the words we use to talk to our students, because all of us have a story of something a teacher once said to us that has stayed with us for ever. The teachers from my primary school inspired the course of the rest of my life; their kindness and commitment stay with me today and hopefully filter down into my own teaching. The majority of the time, what we remember from our own interactions with teachers will have been an act of kindness, words of encouragement from someone whose class we loved. On very rare occasions it might have been something more spiteful that was said, a doubt of what could be achieved that became the fuel that kept a fire burning inside us, becoming a goal to prove somebody wrong. But be in no doubt that teachers are out there every day doing more than what is written in their job descriptions.

Every speech I make, at whatever event I attend, includes a thank you to the teachers who have gathered to hear me. It is not often as a teacher that you are appreciated for what you do, so I was just lucky that the Global Teacher Prize brought people to say thank you to me. After my win, I got hundreds of messages from current and former students, congratulating me and telling me what an impact I had made on their own lives. It might have been something small I'd said, or a big intervention, but they told me it had stayed with them, that somehow, knowingly or perhaps not, I had planted a

seed inside them to guide their path – and it had grown. I only wish more teachers received those types of letters. I hope this book inspires you to reach out to the teacher that changed your life.

I love my job, I love my students, and however exciting it has been to visit somewhere new, I have always missed my classroom and my students.

I am proud to be a teacher.

I am proud to be a member of Alperton Community School.

No matter where I go, or what I do, the days spent in the classroom will *always* be my greatest achievement.

Andria

Acknowledgements

I never, not in a million aeons, thought I'd write a book about my story. I've been fortunate over the past few years to have been inspired and supported by so many individuals that it would be impossible to thank them all... although I'm going to try.

Firstly, I would like to thank my incredible colleagues and students at Alperton Community School. It is my privilege to work alongside you all, even during wet play, bus stop and lunch duties, and PD Mondays. There must be magic in the walls there!

To my extraordinary agent Rachel Mills: thanks for keeping me on the straight and narrow (and on Planet Earth), and thanks to Heather Mills for kicking everything off. Thanks to the amazing team at Bloomsbury, among them Alexis Kirschbaum, Angelique Tran Van Sang, Jasmine Horsey, Lauren Whybrow, Greg Heinimann, Genista Tate-Alexander and Jonny Coward, for having faith and patience, and for giving me the confidence to share my story.

This book would not have been possible had it not been for my extraordinary ghostwriter Anna Wharton. Anna, I absolutely loved our chats and my homework.

I would like to thank Sunny Varkey and all his marvellous team at the Varkey Foundation for creating the incredible award that brought us here to this page. I still pinch myself every day that I am one of the very few chosen to represent your prestigious award.

To all my ladies JoJo, Andrea, Nicola, Vnita, Laxmi, Indi, Candise and Manders; you are my true teachers.

To Potsy, Sunshine Man and soul sister V. Only God knows where I would be without you three.

Mum, Dad, Mary and Christopher and my extended family – which basically means all of Cyprus and Greece – you are everything to me.

Finally, to my remarkable and always patient husband John, my daughters Sophia and Anna Maria. You are the source for my inspiration and achievements.

Disclaimer

This book has been published without input and/or approval from Alperton Community School and any views expressed in the book do not reflect the views of the School.

About the Author

Born and raised in London to Greek-Cypriot parents, Andria always knew she wanted to work in education. After university, she joined the staff of Alperton Community School in Brent on the outskirts of London as an art and textiles teacher; and, fifteen years later, is now part of the school's leadership team.

In 2018, Andria was awarded the Global Teacher Prize from a field of outstanding educators from all over the world. Using the million-dollar prize money, Andria founded a charity called Artists in Residence (AiR) with the aim of improving arts education in schools, and is an international keynote speaker and consultant in arts education.

Andria has been named in the *Evening Standard*'s 1000 Londoners List, is a Culture Leader for the World Economic Forum, and a member of their Global Future Leaders Council. In 2019 she was awarded an MBE for her outstanding contribution to education.

@Andriazaf

About Artists in Residence

Artists in Residence (AiR) is a transformative charitable organisation that creates opportunities for students to meet and work with artists, designers and cultural organisations. These residences offer students the chance to develop artistic skills, create lasting relationships with practising artists, and envision a career in the artistic industries. AiR also supports schools and teachers by providing a more well-rounded creative curriculum, and shows the value – and importance – of an arts education. Some of AiR's artists include Michael Attenborough CBE, Mark Wallinger RA, Armando Alemdar, Fertile Ground and Sarah Pimenta.

A Note on the Type

The text of this book is set in Joanna, a transitional serif typeface designed by Eric Gill (1882–1940) in the period 1930–31, and named for one of his daughters. The typeface was originally designed for proprietary use by Gill's printing shop, Hague & Gill. The type was first produced in a small quantity by the Caslon Foundry for hand composition. It was eventually licensed for public release by the Monotype foundry in 1937.